THE ACCIDENTAL ARCHIVES OF THE ROYAL CHICANO AIR FORCE

 THE WILLIAM & BETTYE NOWLIN SERIES
in Art, History, and Culture of the Western Hemisphere

THE ACCIDENTAL ARCHIVES OF THE
ROYAL CHICANO
AIR FORCE

STEPHANIE SAUER

INTRODUCTION BY ELLA MARIA DIAZ, PHD

UNIVERSITY OF TEXAS PRESS, AUSTIN

Requests for permission to reproduce material
from this work should be sent to:
 Permissions
 University of Texas Press
 P.O. Box 7819
 Austin, TX 78713–7819
 http://utpress.utexas.edu/index.php/rp-form

The paper used in this book meets the minimum requirements of
ANSI/NISO Z39.48–1992 (R1997) (Permanence of Paper). ∞

LIBRARY OF CONGRESS CATALOGING-IN-PUBLICATION DATA
Sauer, Stephanie, author.
 The accidental archives of the Royal Chicano Air Force /
by Stephanie Sauer ; introduction by Ella Maria Diaz, PhD — First edition.
 pages cm — (The William and Bettye Nowlin series in art, history,
and culture of the Western Hemisphere)
 Includes bibliographical references.
 ISBN 978-1-4773-0870-7 (cloth : alk. paper)
1. Royal Chicano Air Force. 2. Mexican American arts—California—History.
I. Diaz, Ella Maria, writer of supplementary textual content. II. Title.
III. Series: William & Bettye Nowlin series in art, history, and culture
of the Western Hemisphere.
 NX512.3.M4S28 2016
 704.03'6872073—dc23 2015024076

The Accidental Archives of the Royal Chicano Air Force represents over a decade of observations, recordings, listening, writing, participations, and other modes of fieldwork on behalf of multidisciplinary artist Stephanie Sauer. In this introduction to her collection of primary sources on the Royal Chicano Air Force, a vanguard Chicano/a arts collective from Sacramento, California, I do not intend to explain what these archives are, or why Sauer deems them accidental. Nor will I overly emphasize my interpretation of these records for fear that I may break the fourth wall of the narrative and influence the reader's experience of this expansive collection. Rather, my introduction to this prolific gathering of archival materials seeks to contextualize them by briefly introducing the curator and the deeper questions she poses regarding the politics of institutional archives and collections—from their construction of knowledge to their complicit role in public assumptions of historical truth. In doing so, I also elaborate on the artistic and literary themes on which Sauer draws to relate the documents and objects she has recovered.

Stephanie Sauer was born in Rough and Ready, California, a tiny town near the California and Nevada border whose major claim to fame is that it briefly seceded from the Union during the American Civil War.[1] This is an important and defining detail of Sauer's biography, which also includes growing up in a family of carpenters and hunters, childhood years spent swimming in the Yuba River, and family elders who taught her how to sew, cook, can and preserve foods, care for livestock, and farm. The art of making things by hand sustained Sauer throughout her life as she pursued craftsmanship in her arts practice, founding her own press (Copilot) in 2008, which specializes in hand-bound books and printed matter.

* The author of this introduction recommends that you do one of the following:
a) Skip the introduction
b) Read the introduction after you finish reading *The Accidental Archives*
c) None of the above

Returning to Rough and Ready's secession, the rebellious spirit of her townspeople is marked by being on the wrong side of history, a fact that was not lost on Sauer while she finished high school in Colima, Mexico, at the Tecnológico de Monterrey. Sauer was able to study abroad in Mexico through an exchange program offered by "El Tec" and her public high school, Nevada Union. The program was established and run by two women, one from each of these respective schools, and one being her high school Spanish teacher, who Sauer describes as "a hippie who also taught us about the School of the Americas and other political realities at the time."[2] Set against a secondary education in Northern California that simultaneously engrained and disrupted principles of Manifest Destiny and visual and historical tropes of the "Wild West" and "gold country," Sauer encountered a different master narrative in Mexico: the colonial processes that shape and disseminate history as a method for nation-building and citizen-making, for enforcing geopolitical borders and mythologizing wars, for forming opinions about here and there, as well as feelings of us and them.

Sauer worked from 2002 until 2004 at La Raza Galería Posada, in Sacramento, California, first as an intern and then as the ArtChives coordinator. A historical center for Chicano/a and Native American literature, art, and culture, La Raza Galería Posada (LRGP) was first founded as a bookstore in 1972. RCAF member and Chicano/a art scholar Terezita Romo recalls that she joined the staff "when it was just a bookstore and had been the UFW [United Farm Workers Union] office and then COPA [Chicano Organization for Political Awareness]" (2007). She also named several of the bookstore's original founders—"Philip Santos, Pete Hernández, Gilbert Gamino, Juan Gutierrez and Louie 'The Foot' [González]" (2007). Romo added that La Raza Bookstore had been a place for the display, sale, and collection of RCAF silkscreen posters. In 1979, Romo "asked [Philip] Santos if we can use the other space as a galería," when the adjoining dry-cleaning business closed and the space became available (2007). After writing a grant and fund-raising with the M.E.Ch.A. Chapter at Sacramento State University, Romo and the staff launched La Galería Posada in 1980. "The first exhibit was of the work of José Guadalupe Posada, an influential, Mexican artist," writes Philip Santos in the

introductory note to the catalog for La Raza Galería Posada's *Quinceañera* show (1988, 1). Soon, LRGP's exhibitions of Chicano/a posters and other visual art became important social events and gatherings for Sacramento's Chicano/a community and for the RCAF.[3]

Thirty years later, Sauer, among a cohort of second- and third-generation LRGP workers and volunteers, was tasked with the duty of meeting with RCAF members and key community activists to record memories of their lives, involvement in the bookstore, and stories about making art in the 1960s, 1970s, and beyond. Asking questions and recording their answers by hand or with audiocassette tapes, Sauer, who was also completing a specialized bachelor's degree in Chicano/a Literature and Arts at Sacramento State University, was edging the disciplinary borders of art history, oral history, cultural studies, and anthropology. She wasn't alone in this documentation process, as Josie Talamantez, an RCAF member and the retired director of programs for the California Arts Council, was also busy interviewing and filming RCAF artists about their historical participation in the Chicano Movement, UFW activism, and production of Chicano/a art over the past forty years.

This is important context for *The Accidental Archives* because it was in this capacity and with a background in tactile experience (sewing, gardening, and other meditative acts that involve attention to detail, manual labor, and discipline) that Sauer began to reexamine what she was doing. What did it mean to sit down and ask someone questions about his or her life amidst historical events? How does one translate what Tino Villanueva calls the "sound texture" (2000, 694) of English, Spanish, and caló, intermingled with slang, or site-specific references? Interviewing RCAF members such as José Montoya, Esteban Villa, Juanishi Orosco, Stan Padilla, Luis González, Armando Cid, Josie Talamantez, and others, Sauer also encountered a unique aural experience when she heard RCAF members' use air force vocabulary and expressions like "impudent pilot," "General Disaster," "Major Confusion," and "locura lo cura," or craziness cures. The RCAF used a distinctive vernacular to describe themselves, their antics, and the historical events through which they lived. As it often happens with historians and, sometimes, anthropologists, Sauer struck up friendships, and her professional work became her personal life. Soon

the stories told to her became more humorous but complex, and more vivid but incomplete, as the RCAF members she interviewed forgot the last names or the first names of the people they mentioned, relayed exciting stories in keen detail but were uncertain of dates and times, and told conflicting accounts of the same story.

Working with partial histories and contradictory memories, Sauer experienced the insecurities and frustrations on which Dolores Hayden comments in *The Power of Place: Urban Landscapes as Public History* (1997). Noting the negotiations and compromises involved in documenting and building a public memory of local history, Hayden's book reveals both the forgotten histories and the processes of their recovery. Much like Sauer, Hayden's Power of Place—as both a text and an organization— was prompted by a haunting question concerning the official sights/sites of history in the US built environment: "Where are the Native American, African American, Latino, and Asian American landmarks?"(7). By founding the Power of Place in Los Angeles, Hayden sought to preserve historical sites of the *other* Los Angeles, or the histories left out of the official maps and organizations of the city. To do so, she worked with artists, community members, historians, students, and local city planning agencies on the Biddy Mason Memorial honoring a nineteenth-century slave woman who strategically won her freedom, became a community touchstone as a midwife and general healer, and whose homestead at 331 Spring Street was a paved parking lot by 1986 (169).[4]

After a public workshop that included students and faculties from several departments at UCLA, artists were employed to reinterpret the historical site of Mason's home.[5] Artist Sheila Levrant de Bretteville was especially important to the memorial, designing an eighty-one-foot installation wall. Hayden writes that Levrant de Bretteville's permanent piece "transformed a marginal alley behind several large buildings into a significant public place" because of its dynamic approach to historical narrative (181). The timeline organized Los Angeles history according to decades, telling "the story of Los Angeles's development from a tiny Mexican town to a thriving city" (181). Interspersed in Los Angeles's evolution was the "story of Mason's walk across the country, arrival in Los Angeles, her suit for freedom, and her thriving practice as a midwife" (181). By

locating Mason on the map of Los Angeles's larger historical context—the demographic shifts and changes to the built environment brought about by annexation, abolition, industry, and economic development—the wall "encouraged a viewer to contemplate change on Spring Street in both space and time" (187).

Despite the nod that Hayden gives to the artists, residents, researchers, and city workers involved in the Mason memorial and other Power of Place projects, she acknowledges the uncertainties and concessions that historical collaboration causes between these often disparate groups. How does the historian work with a person who *lived it*, or remembers the past from a personal experience? How does an artist translate historical evidence in a factual way, if at all? "All of the participants in such a process transcend their traditional roles," Hayden answers, adding,

> [f]or the historian, this means leaving the security of the library to listen to the community's evaluation of its own history and the ambiguities this implies. . . . It means working in media—from pamphlets to stone walls—that offer less control and a less predictable audience than academic journals or university presses do. It also means exchanging the well-established roles of academic life for the uncertainties of collaboration with others who may take history for granted as the raw material for their own creativity, rather than a creative work in itself. (76)

Although Hayden appreciates "public art as a route to public memory," she confesses that working with artists, as well as the other project participants, is an uncomfortable process for a historian. Cross-community collaboration is akin to interdisciplinary studies and, as Hayden notes, "interdisciplinary, community-based projects are not always easy to accomplish" because borders must be crossed, methods must be blurred, and multiple points of view must be valued (77).

No surprise that Hayden was critiqued in the academic journals and scholarly reviews of her book for not elaborating in analytical detail on the commissioned artworks, like the Mason memorial. Elizabeth Grossman finds Hayden's modest remarks on the public artworks outlined in her book to be deficient: "What is most disappointing, particularly given

Hayden's gift for design analysis, is her minimal discussion of the physical projects themselves" (1995, 25). But Hayden's "minimal discussion" of the artworks pertains to the Power of Place's collaborative process, which gave "less control" over the history to the official historian (76). Having worked with artists, community members, researchers, and planning agencies, Hayden curtails her authoritative voice in the textual interpretations of the public art projects to extend the collaborative process to her readers, who she hopes will form their own opinions and participate in the concept of a shared, public history by reading her book.

Readers of *The Accidental Archives* will discover that Sauer confronts many of the same challenges that Hayden does in the hunting, gathering, and sharing of the RCAF's history. Like Hayden, Sauer welcomes readers to follow her through the archive, but she turns in a different direction than Hayden by suspending historical realities, leaping through epochs and between conversations with various historical figures, dead and alive, to offer readers an intimate experience of RCAF history: her deeply personal, biased, and shared witnessing.

In fact, Sauer prepares readers early on in the catalog for a messy and subjective historical encounter. Following *The Accidental Archives'* table of contents and a page of suspicious epigraphs, Sauer presents a two-page roster of names as a "Cast" with the disclaimer: "[The majority of whose work goes unrecorded in official historical documentation of the Royal Chicano Air Force, including this very catalog, even despite the author's meticulous efforts and unbiased record-keeping practices]" (000). Sauer's "Cast" of names moves in a nonlinear, nonvertical, and nonhorizontal order, a formless shape that, on its left side, is bordered by "JOAQUÍN MURRIETA," a nineteenth-century folk hero mythologized in corridos and a symbol of regional resistance to annexation and discrimination against Mexican Americans following the ratification of the Treaty of Guadalupe Hidalgo in 1848. Sauer's cast also includes "DIEGO RIVERA," "FRIDA KALHO," and "MOCTEZUMA II," next to "FREDDY & THE RCAF BAND," "FAST EDDIE SALAS," "TONY LONG HAIR," and "'TURTLE' RODRIGUEZ" (3–4). These sixteenth-, nineteenth-, and early twentieth-century historical figures, as well as the people listed by their nicknames, are interspersed throughout the list of RCAF members whose

names are more recognizable—"JENNIE BACA," "RUDOLFO 'RUDY' CUELLAR," "JOSÉ MONTOYA," "ESTEBAN VILLA," among several others. Below the "Cast," Sauer inserts her own pun on the bottom line, providing a place for anyone who feels a part of the RCAF, but is left out of the record, to sign his or her name. Sauer politely instructs: "All others, favor de sign here."

The "Cast" of characters with an option for signing and, thereby, entering the historical record, is one of the first clues Sauer gives readers to the creative liberties she takes with the documentation of the RCAF in *The Accidental Archives*. In this playful and preliminary experience of the catalog, Sauer draws on literary devices and elements from magical realism, in which the story line of a novel merges the spaces and times of several centuries, moving the plot forward through supernatural events that are regarded as commonplace by the characters. In "An Overview of RCAF History," for example, Sauer begins the historical synopsis of the 1960s and 1970s Chicano/a arts collective in 1898 with Brazilian inventor Alberto Santos Dumont and his designs of the "Santos No. 20 or Demoiselle (Dragonfly)." She describes this small plane as "made of bamboo, linen, and wire" (20). In a test run of the Dragonfly, Sauer writes that Santos Dumont ran out of linen and used napkins from a bar near his home, discovering that José Montoya had sketched upon them the "perfect accent to his everyman's flying machine" (21). RCAF members adapted Santos Dumont's airplane design, Sauer explains, adding adobe, which made the light plane heavier (21). "Rudy Cuellar, who was a natural mechanic," used fireworks to start it, while "Dr. Arnaldo Solis and Stan Padilla . . . created a ceremonia in which the heavy mass could be lifted into flight with the help of Juan Cervantes' combustible engine research for prolonged suspension" (21). To support her account of the building of an RCAF airplane, Sauer presents photographs from the archive she has amassed, including an illustration of the "inaugural flight of LaRuca 2012" from the Con Sapos Nationalist Museum, an airline ticket stub with the airport code, "Rio—Santos Dumont," as well as a photograph of a plaque from the Santos Dumont Residence in the city of Petrópolis in Rio de Janeiro. Also presented as historical proof is an index card with the following annotation:

At Simon's Bar on 16th Street across from Luna's Café, the balding man
with bright blue eyes asks if Ishi knew that the adobe airplane made
Pablo Neruda laugh.

Francisco Something had told the balding man this.

In her textual record and collection of archival evidence, it is clear that
Sauer is moving through centuries and geographies to make a point
about the tensions between oral cultures and Western notions of histori-
cal truth. Building the RCAF aircraft, like an archive, is one part myth,
two parts homage, and the final part is Sauer's role as the listener/
recorder/mediator. Readers can almost see Sauer leaning in while Ishi
and the balding man with bright blue eyes converse, only to be frustrated
by his lapse in memory over Francisco's last name. Thus, Sauer's writ-
ten account in "An Overview of RCAF History" coincides with her visual
evidence because what is factual and truth is conveyed to readers in the
same way she has collected it: in bits and pieces.

Returning to *The Accidental Archives*' "Cast" of characters, Sauer's
inclusion of pre-Colombian rulers and deities, as well as early twenti-
eth-century Mexican leaders, artists, and philosophers, reveals another
essential component of RCAF history and oral traditions. The Chicano
Movement emerged in 1965 around the farmworkers' strike, anti-war
protests, student walkouts, calls for land reclamation, and the liberation-
ist philosophies of 1968. Chicano/a artists, poets, intellectuals, and activ-
ists revisited their origins, asking, "¿Quien Soy Yo?" and responding with
Yo Soy Joaquín (Gonzáles 1967), among other epic poems and political
manifestos like *El Plan Espiritual de Aztlán* (1969). The poetry, posters,
and plans drew on Mexican revolutionary artists, thinkers, and political
leaders to articulate Chicanismo, a cultural, political, and spiritual con-
cept of identity for Mexican Americans who no longer wanted to adhere
to the melting pot logic of nationalism in the United States (Valdez 1972).
Instead, Chicano/a artists, activities, leaders, and intellectuals traced a
modern identity for Chicanos/as in the late twentieth century across geo-
political borders between the United States and Mexico, and crisscrossed
the borders of US and Latin American histories.

The RCAF contributed to the building of this self and group conscious-
ness in the 1960s and 1970s Chicano Movement as they spoke, performed,

and painted into being an unbroken and continuous Chicano/a conscious-
ness in dialogue with the Mexican Revolution of 1910 and pre-Colombian
civilizations. Drawing on the educational and revolutionary art philoso-
phies of "los tres grandes," or the early twentieth-century Mexican mural-
ists Diego Rivera, José Clemente Orozco, and David Alfaro Siqueiros, the
RCAF also employed Joaquín Murrieta, Moctezuma II, Frida Kahlo, José
Guadalupe Posada, and other historical artists that preceded their his-
torical moment to talk about Chicano/a art from a decolonial perspective
of US history. Therefore, the presence of Diego Rivera, Joaquín Murrieta,
Moctezuma II, Frida Kahlo, and others in *The Accidental Archives* allows
readers to enter into the RCAF's aural experience in the 1960s and 1970s,
side by side with members as they told stories to each other and to the
Chicano/a community about who they were and what they were doing.

Moreover, this anachronistic method for ordering the RCAF archive
lets readers simultaneously witness Sauer's early twenty-first-century
experience of listening to RCAF recollections, or re-articulations, of
their conversations about late nineteenth- and early twentieth-century
Mexican thinkers and artists, espousing concepts like "la raza cósmica"
(Vasconcelos 1925), which framed Chicanismo and the group's founding
principles. In other words, the past is present in *The Accidental Archives*'
organization of RCAF history. Subsequently, Sauer perceives the lapses in
RCAF memories, or the members' offerings of incomplete names, places,
dates, and conflicting perspectives of events as an opportunity to let them
be—to coexist. In doing so, she captures the RCAF's history as it hap-
pened to her in the twenty-first century, raising questions about whose
past gets preserved at the site/sight, sound, and moment of history. The
blurriness of *The Accidental Archives*' historical accuracy makes readers
wonder why certain "people, places, and things"[6] are implicitly acknowl-
edged as historical, while others only become invaluable long after they
are paved over and most of their primary sources are lost to posterity.

The suspicion Sauer infuses into her archival evidence of RCAF history
is also a politically subversive strategy, or a way to document Chicano/a
history that safeguards the speakers who took sobering risks in the 1960s
and 1970s, and are now asked to tell the truth and nothing but the truth.
For example, when readers of *The Accidental Archives* encounter the
interior spaces of RCAF planes, where members like Juanita Polendo

Ontiveros "house the sewing machines used to make huelga flags at a moment's notice" (000), the urgency of the farmworkers' strike in 1965 is conveyed. In Sauer's descriptions of the "Powered Squeegee," or "the most elusive plane in the entire RCAF fleet" that was "flown by Captain Louie 'The Foot' González," readers learn that it was actually the "undercover graphics operation for huelga posters for UFW strikes" (32). In between the fantastical possibility of RCAF airplanes that flew, Sauer imparts a historical truth about the stakes of the farmworkers' strike and what the RCAF did on its front lines. The RCAF flew planes not just to attend farmworkers' protests, but to produce art that bolstered resolve and built solidarity with posters that proclaimed, "VIVA LA HUELGA!!!" and "BOYCOTT GRAPES!!!"

Similar to El Teatro Campesino's actos, or the impromptu and brief performances in which farmworker actors performed on the beds of farm trucks in the earliest years of ETC, the RCAF produced UFW posters inside their airplanes (Elam 1997, 75). Their posters, like ETC's performances, served an immediate audience and purpose. Rooted in histories of labor—both farm work and artwork—the RCAF plane was "a dual symbol" for farmworker audiences, reminding viewers of "those other flatbeds that served as the primary means of transportation for the migrant farmworkers," and also a space that "connoted and promoted rebellion" (Elam 75). As a space of rebellion, the RCAF airplane defied traditional notions of where art can happen. Thus, the "adobe airplane" was a coded term for the RCAF, humorously referring to using vehicles as on-site centers for art production, all of which are chronicled in the "Flight Logs" of Sauer's section on the RCAF's "Flight Maneuvers."

Leveling the playing field between fact and fiction, Sauer's appropriation of magical realism literary devices privileges myth in the historical records of the RCAF, working both with and against the institutional definitions and values of the archive (Echevarría 1984). Magical realism, a genre that deals with myths or "stories whose main concern is with origins" (Echevarría 1984, 359), is equally concerned with history—both its making and its edifice, or where it is housed, located, and accessed in relation to the social body that made it. Roberto González Echevarría notes that "the duality" of myth and history "is present throughout *Cien*

años de soledad separating the world of writing from the atemporal world of myth. But the play of contradictions issuing from this duality reaches a synthesis that is perhaps the most important feature of the novel," since "myth represents origin" (370). Making art for the people and fashioning an air force persona, the RCAF performed into being a legend of a Chicano/a air force that was mythologized as soon as it happened. One could say that all RCAF history originates in myth.

With the presence of the supernatural in Gabriel García Marquez's classic work of magical realism, *One Hundred Years of Solitude*, history "dwells in a special place," González Echevarría writes (371). The records and documents of generations of the Buendía family are stored in "Melquíades' room in the Buendía house," which Echevarría chooses "to call the Archive," a room "full of books and manuscripts, and that has a time of its own" (371). In *The Accidental Archives*, readers find that RCAF history dwells inside Sauer's catalog and it also has a time of its own.

Melquíades' room in *One Hundred Years of Solitude* has far-reaching implications for Latin American history, which Echevarría perceives as the colonial processes of ordering the physical world as well as the world of knowledge: "The Archive is, first of all, a repository for the legal documents wherein the origin of Latin American history are contained, as well as a specifically Hispanic institution created at the same time the New World is being settled. . . . America was discovered by Columbus, but really became a historical entity as a result of the development of the printing press. Latin America was created in the archive" (379). Echevarría claims that the New World comes into being through conquest and the recording of conquest that occurs during the colonial period, both of which pertain to *The Accidental Archives*. The mapping of the "New World" encompasses the mapping of knowledge, and the historical consciousness of that knowledge is the origin from which readers understand their contemporary world and its history.

Archives are thus powerful because they are "the law of what can be said, the system that governs the appearance of statements as unique events" (Foucault 129). But, as Michel Foucault carefully adds, the archive is not only the principle and regulation of knowledge; it is its order—the system of its organization. In other words, the archive is more than the

assemblage of the stuff of history; it "determines that all these things said do not accumulate endlessly in an amorphous mass" (129). Documents are not history without their interpretation, filing, indexing, and presentation to a reading and/or discerning audience. Thus, the archive "is that which, at the very root of the statement-event, and in that which embodies it, defines at the outset *the systems of its enunciability*" (Foucault 129). For history to have happened, it has to be known; and for it to be known, someone with knowledge of archival practices—either Melquíades in his room inside the Buendía house, or Sauer listening patiently to a bald man remembering partial truths at Simon's Bar—has to have a hand or foot in both the colonial world (the archive) and the world waiting outside Western knowledge and its systems of interpellation.

The RCAF's realm of sociopolitical resistance, Chicanismo, and myth is one such world that occurs outside the Western one and navigates an unsteady entrance through its volatile atmosphere. Sauer alludes to the RCAF's tense negotiation of resistance and acceptance of institutional archives in the section "La NASA Sapotécnica Incident*," which she footnotes with an explanation that the incident is actually one of a series of "The Archivist's Dreams." More of a nightmare, the footnote vulnerably conveys a blurry encounter with the FBI, spies, and other enforcers of the law of the land meant to contain and control the RCAF's ruptures of the master narrative of history; or, in other words, to quell the activists of the 1960s and 1970s civil rights era, who talked back to power (Lipsitz 2001, 73).

In the "Archivist's Note," Sauer addresses the far-reaching implications of the colonial ordering of the world, the world of knowledge, and its enforcement. She explains to readers of *The Accidental Archives* her role as "La Stef" and her archival choices in ordering the RCAF's history both with and against institutional practices: "I began the arduous task of documenting, preserving, restoring, organizing, collecting, categorizing and cross-referencing the whole historical truth of the Royal Chicano Air Force (RCAF) several lifetimes ago, when I was incarnated and initiated in a body much different from this current one. A body composed of small pores and broad hands. I was mute but not deaf and put to work as a keeper. I kept the adobe. I kept the secrets. We did not have writing,

but I was born with memory then. I was born with seeing. Now I need evidence. I need documentation" (11). Sauer as La Stef suggests that she is the RCAF's Melquíades in *One Hundred Years of Solitude*. She is not a relation of the Buendía family (or a Chicana), but she is an insider and outsider of the family, since she is omnipresent in the catalog; she sees all and remembers everything, but doesn't speak the prehistory of the RCAF. La Stef, the keeper, also echoes in Melquíades' transformation from the gypsy, who appears at the beginning of *One Hundred Years of Solitude*, introducing José Arcadio Buendía to a host of worldly technologies, and returning at the end of the novel as the chronicler of the Buendía family. Along La Stef's journey through the beginning and ending of worlds, she shape-shifts and is reincarnated, until the systems of record- (and secret-) keeping change like they never have before.

In a defiant act against the new ordering of her very old world, La Stef decides "to create entire libraries of proof" with her now delicate hands "able to move through manila files and ephemera at a superhuman pace, able to document meticulously in red and black ink" (11). It is no coincidence that Sauer, as the RCAF archivist La Stef, records events and happenings in red and black ink. Evoking the Nahuatl word for the writings of books, which is "in tlilli in tlapalli," translating literally to "the black [ink], the red [ink]" (Boone 2000, 21), La Stef embodies an indigenous scribe under layers of Eurocentric knowledge and training as an archivist.

While not (supposedly) part of the archive—or the history that the archive is supposed to objectively keep and disseminate—Sauer's "Archivist Note" communicates the splitting of the sacred from the intellectual in ways that parallel Gloria Anzaldúa's embodiment of the scribe, who is the historical consciousness of a people and, therefore, a sacred person. In "Tlilli, Tlapalli / The Path of the Red and Black Ink" from *Borderlands/ La Frontera: The New Mestiza* (1987), Anzaldúa writes,

> In the ethno-poetics and performance of the shaman, my people, the Indians, did not split the artistic from the functional, the sacred from the secular, art from everyday life. The religious, social, and aesthetic purposes of art were intertwined. Before the Conquest, poets gathered to play music, dance, sing and read poetry in open-air places around the

> *Xochicuahuitl, el Árbol Florido*, Tree-in-Flower. . . . The ability of story
> (prose and poetry) to transform the storyteller and the listener into
> something or someone else is shamanistic. The writer, as shape-changer,
> is a *nahual*, a shaman. (88)

Coinciding with the oral histories and archival work Sauer was complet-
ing as the ArtChives coordinator at La Raza Galería Posada in the early
twenty-first century, other institutions were forming collections for the
RCAF. This explains why La Stef and her Con Sapos team "no longer
guard the adobe" since "that task has been taken up by an appointed sub-
committee of the Board of Directors, operating under 501(c)(3) status.
I now share upkeep duties with the Impudent Young Pilots of the third
and fourth generations—soon to be fifth, including bi-weekly dusting of
all control panels in the aircraft fleet" (11). Embedded in her fantastical
explanation of La Stef's archival practices and her loss of them—since
she is reassigned to dusting duties for the RCAF aircraft fleet—Sauer
confronts the politics of archiving, or "the systems of enunciability" that
make history recognizable (Foucault 129).

On May 5, 1988, the Royal Chicano Air Force deposited their artworks
and records at the University of California, Santa Barbara. The RCAF's col-
lection was maintained for five years in the Colección Tloque Nahuaque
under the direction of archival librarian Salvador Güereña. In 1993 it
moved to the university's institutionally integrated archive, the Califor-
nia Ethnic and Multicultural Archive (CEMA), and became part of a major
engine of archival research for four major ethnic groups in California.[7]
The RCAF's collection was processed in the late 1990s, and by the early
twenty-first century images of RCAF posters, murals, and historical events
became available through Calisphere, the University of California's online
catalog of primary sources.[8] Historically, the RCAF was active and always
headquartered in Sacramento, raising questions about why this local
Chicano/a arts collective deposited its archives outside the region.

Back in Sacramento, the RCAF's lack of place at the local university,
Sacramento State (CSUS), reflected the larger predicament of Chicano/a
art in the 1980s and 1990s. The RCAF made many strides in regional and
mainstream visibility, but Sacramento State did not seem to notice. Both

Esteban Villa and José Montoya were art professors at CSUS from 1969 until the 1990s; many of the RCAF members graduated from the university. While CSUS was a major hub for the RCAF throughout the late twentieth century, the university library made no major efforts to collect RCAF art or historical artifacts for its archive until 2007, long after the group donated its private collections to CEMA in 1993.[9] RCAF artist Ricardo Favela explained,

> There was two main reasons we decided to go and house our archives there. Number one was very simply, they asked us. And this is something that CSUS can't get over. They never asked us. If they would have asked us they would have had it. But they never asked us because we were hidden in plain sight. . . . the other reason why we decided to go with Santa Barbara was because they are the only institution I believe in the whole of the United States that has a Master's program and I believe a PhD program in Chicano/a art history. So they—it was incumbent upon them to collect a very good collection of Chicano material. (Lemon 2001)

As Favela recalled, the RCAF remained "hidden in plain sight" at CSUS during the 1980s and 1990s, despite the visibility of RCAF murals in Sacramento like *Southside Park Mural* (1977; 2001), *Metamorphosis* (1980), and *L.A.S.E.R.I.U.M.* (1984; 2000), as well as its participation in countless local and regional exhibitions of Chicano/a art.

The breadth and quality of a university's collection of Chicano/a materials is directly linked to the development and proliferation of its Chicano/a Studies program or curriculum. CEMA director Salvador Güereña makes this point very clear in "Archives and Manuscripts: Historical Antecedents to Contemporary Chicano Collections" (1988). Reviewing the history and the politics of Chicano/a archives, Güereña states that "those university collections which advanced the farthest did so synchronously to the growth and sophistication of the Chicano academic infrastructure on their campuses" (1988, 5). UC Santa Barbara's Chicano/a collection demonstrates the correlation. One month after the Chicano Youth Conference in Denver, Chicanos/as organized the Mexican American Studies Conference at UCSB.[10] The meeting led to *El Plan*

de Santa Barbra, a key planning document for all Chicano/a Studies programs and, specifically, for the development of Chicano/a academics at UC Santa Barbara. Güereña adds that CEMA's Chicano/a collection "is the only discrete research collection that operates as part of a university library" (7). Completely entrenched within the institutional infrastructure of the Department of Special Collections, the collected works were first named the "Colección Tloque Nahuaque" in 1968 (Güereña 7). The collection was "conceived through the initiative of members of the United Mexican-American Students and the staff of the Center for Chicano Studies" (Güereña 7). Güereña writes that the evolution of the collection, which was started through student and staff initiative, "was supported by the University Library administration" (7). Thus the history of Chicano/a resources at UCSB reveals a history of institutional support.

The RCAF's collection at CEMA contributed to its visibility in the first national Chicano/a poster art exhibit in 2000. Organized by the University Art Museum at UC Santa Barbara, *Just Another Poster? Chicano Graphic Arts in California* relied heavily on the RCAF poster collection at CEMA. Between 2000 and 2003, the exhibit toured the University of Texas at Austin, the University Art Museum at UC Santa Barbara, and Sacramento's Crocker Art Museum.[11] The title of the show, *Just Another Poster?* is based on Luis González's 1976 silkscreen, *This Is Just Another Poster*, which also adorns the cover of the exhibit catalog.[12]

Likewise, UC Santa Barbara advertised the exhibition with an RCAF poster by Ricardo Favela that he signed "© 1975 RCAF," emblematic of the group's collective consciousness during the 1970s, which espoused group solidarity over individual notoriety. Favela's poster features two *calaveras* dressed in contemporary clothes. One of the skeletons holds a frame up to the other's face. Favela created the poster as an advertisement for the RCAF's Centro de Artistas Chicanos, an umbrella organization founded by the RCAF in 1972 to teach and make art and to support other community services. The poster's original advertising function is conveyed by the text below the image: "Posters, Murales Y Clases de Arte Para la Gente." But Favela's poster takes on new meaning as an announcement for the 2001 *Just Another Poster?* show. As one of the *calaveras* attempts

to capture the other's likeness in a frame still dripping with fresh paint, the image playfully comments on the new appeal and collectability of Chicano/a art in the twenty-first century.

Amidst the success of their collection in Santa Barbara, the RCAF grew increasingly aware of their absence in the university archives and collections at CSUS. Echoing Ricardo Favela, José Montoya remarked on Sacramento State's neglect of the RCAF and the uneven development of Chicano/a history and departments in general:

> We've been interviewed and researched and there's very little out there that we can send our students to go and read those books—even at Sac State. For all of the things that we accomplished as the Royal Chicano Air Force, they're finally—just barely—beginning to say, "Well, you guys came from here. Why is your archive in Santa Barbara?" Well, no one asked. Now they've got new librarians who are saying, "You have to have your stuff here." So I'm having to, you know. I will give them some of the Barrio Art materials because it's still going on and still a CSUS affiliated program. The poster-making—Favela, who teaches in the art depart-ment, has turned the collection over to them—or set up an archive. Nothing is as expansive, or close to having everything we've ever done like Santa Barbara. (José Montoya, Interview, July 5, 2004)

As Montoya indicates, institutional efforts to collect RCAF art and records at CSUS did not get under way until their CEMA collection was well-established. As head of the Department of Special Collections and University Archives, Sheila O'Neill joined the CSUS staff in 1999 and is one of the "new librarians" to whom Montoya refers as a recent advocate of RCAF archives at the university library. Following mayor Joe Serna Jr.'s death in 1999, O'Neill was contacted by his staff in 2000, and his "papers came to the library December 2004 and were processed during the year 2006–early 2007."[13] The Joe Serna, Jr. Papers officially opened to the public on October 21, 2007.[14] "During that same month, the library hosted an exhibit titled 'Our Mayor Forever: Joe Serna, 1939-1999.'"[15] Serna was an RCAF member and, along with his collection at Sacramento State,

O'Neill and her staff prepared another RCAF member's collection: the Dr. Sam Ríos Papers, which includes documents on the founding of Chicano Studies at CSUS; the early years of Breakfast for Niños, a breakfast program in Sacramento started in the 1970s for low-income students; and the development of the Washington Barrio Education Center.

In the twenty-first century, the anxieties provoked by the acquisition and official archiving of historical records in the very institutions that underrepresented communities struggled for access to and visibility in pervades *The Accidental Archives*. While Sauer's catalog raises the same questions that Dolores Hayden poses in *The Power of Place*, it is also powerfully subversive because it works against institutional practices for collecting history. Thus, Sauer's catalog resonates in other public art interventions that operate unofficially, enacting spatial tactics to remap the forgotten histories of communities of color.

In 2002, artist Sandra de la Loza founded the Pocho Research Society (PRS) in Los Angeles and intruded on the city's built environment through a series of public art projects that are recorded in the PRS's *Field Guide to L.A.: Monuments and Murals of Erased and Invisible Histories* (2011). In the opening image of the field guide, de la Loza presents herself as a guerrilla artist: her face is covered by a white face stocking, and her eyes are framed by a piercing frown. Donning the role of a militant subversive, de la Loza and her PRS team performed *Operation Invisible Monument* in which they located, installed, and photographed "a series of plaques at four different locations in and around downtown Los Angeles" (5). The plaques commemorated key events in local Chicano/a history, a history far removed from the visual archive of the American imagination of "the West" and "the frontier."

One of the monuments that de la Loza and her crew landmarked was at La Placita Olvera, near 650 North Main Street in Los Angeles. This is the site of Mexican artist David Alfaro Siqueiros' mural, *Tropical América* (1932). While the mural is now officially restored and on view (with an Interpretive Center officially opened October 9, 2012), the PRS installed its plaque in 2002, detailing the mural's creation, the sponsors' original expectations that it would feature "lush tropical vegetation," and Siqueiros' delivery of politically charged imagery, including "a crucified

indigena with a descending eagle representing American imperialism" (2011, 6). Subsequently, the PRS plaque notes that "the piece caused much scandal" and was covered and then the entire work whitewashed within six months (6). While *Tropical América* is now restored, celebrated, and even perceived as aesthetically pleasing since its "social and political context" is no longer "fresh" and has been "forgiven" (Pitman Weber 2003, 14), de la Loza notes in the PRS *Field Guide* that her plaque "was taken down five hours after it was installed" (15). Unlike Siqueiros' mural, the PRS plaque was too fresh and completely unforgivable. It didn't have the right to public space or, apparently, the right to tell the history of Los Angeles.

In many ways, the RCAF members in *The Accidental Archives* are Sauer's unofficial monuments. The RCAF and the stories that people told Sauer over several years of interviews transcend oral history and transform into monuments. In other words, RCAF memories are tall tales; they are uncontainable monoliths that belong in public parks, public squares, open fields, and other outdoor spaces in which many of the stories took place. Sauer's film accompanying *The Accidental Archives*, aptly titled *The Ancient Documentaries of Southside Park* (2010), makes this point clear. Presented in a section of the catalog, *The Ancient Documentaries* is a short film that chronicles La Stef's discovery of the sacred scrolls of the RCAF and their premodern viewing apparatuses (a sort of prototype of the television).

After tracking the scrolls through various old haunts of the RCAF and the historical gathering places of Sacramento's Chicano/a community, La Stef and her knowledgeable local assistant "Miss Ella" pay a visit to José Montoya at his home in Sacramento's Chicano/a barrio, the Alkali Flat. La Stef seeks Montoya's advice on locating the scrolls because she and Miss Ella get warm to their location, but never warmer. In a scene on Montoya's porch, Sauer makes a critical nod to *The Accidental Archives* as she sits and listens to him talk about the history of the scrolls, which are neo-indigenous codices that visually narrate the Chicano/a ceremonies enacted by Sacramento's Chicano/a community throughout the late twentieth century. Montoya gestures in the scene to the whereabouts of the scrolls' location and hands La Stef a key. While lighthearted, the

gesture is also powerful because it conveys the productiveness of oral history work, which Sauer visualizes in the film as the literal key to unlocking history. By listening to José Montoya—or any elder within a community who has *lived it*—present and future generations of artists, scholars, historians, and archivists have an opportunity to really know history. This is a significant point to make because it means that history needs more than the archive—it also needs people.

If readers of *The Accidental Archives* seek a clear trajectory for RCAF history, they will soon discover that "X" never marks the spot in the catalog Sauer has assembled and interpreted. But they will depart from *The Accidental Archives* wondering if it ever really does. Such wonder is exactly the way one should approach historical truths. It is not accidental in the section under "Infamous Accidents" that La Stef offers readers a primary source, or rather a primary voice, typed out on an index card: "'You're going to confuse archeologists 500 years from now.'—Sam Ríos, PhD" (68). For Chicanos/as and other underrepresented US communities that are often of color, the reclaiming of space—both physically in the environments in which they live, work, and produce culture, as well as in the abstract spaces of history—is always a politically contested and often violent process. *The Accidental Archives* seeks to tell you something about this; but not everything.

To conclude my introduction to *The Accidental Archives of the Royal Chicano Air Force*, I would like to mention my missed opportunity to interview La Stef's native assistant, Miss Ella, for the sake of writing this introduction. I encountered her when I was invited to present a lecture, "Flying under the Radar with the Royal Chicano Air Force," at the Annual Festival of the Arts and Art History at Sacramento State University in April 2013. Held in the library gallery at CSUS, the lecture was in conjunction with an exhibit of RCAF posters that are now on permanent loan to the Department of Special Collections and University Archives from La Raza Galería Posada. Miss Ella had come into the lecture just one minute before I started speaking, and she laid out brochures for her K Street tunnel tour in the back of the gallery.

Titled *Miss Ella's Tunnel Mural Tours*™, the brochure solicits tourists to contact her if they would like a personal tour of the pedestrian

underpass in downtown Sacramento that connects "Old Town" to the K Street Plaza. The passageway houses the RCAF mural L.A.S.E.R.I.U.M., which stands for "Light Art in Sacramento, Energy Resources in Unlimited Motion." Designed by Esteban Villa and Juanishi Orosco in 1984 and renovated in 2000, L.A.S.E.R.I.U.M. is a two-hundred-foot-long mural that spans the entire length of both sides of the tunnel. I noticed Miss Ella, as well as most of her brochures, were long gone before I ended my talk. I wasn't surprised by either, since I too wanted to take her tour and assumed someone of her local knowledge would be irritated by yet another academic showing up to talk about people, places, and things that she knows little about.

After I finished, a good many hands shot up in the air and I was excited that my talk had provoked a response from the audience. But my excitement soon turned to disappointment when the first question I was asked by an art history student was if Miss Ella was available to give a tunnel tour of L.A.S.E.R.I.U.M. She was clutching a brochure in her hand, and I realized that many others in the audience were clutching brochures as well. I replied that, unfortunately, I did not know Miss Ella's whereabouts at that particular time and moved on to the next question amid some uncomfortable laughter from the crowd.[16]

Fortunately, La Stef took Miss Ella's tour, shortly after enlisting her as an assistant in the recovery of the RCAF's sacred scrolls. Surprised by Miss Ella's breadth of local knowledge, La Stef asked her to join the Con Sapos team and add to its centuries of RCAF records, artifacts, and stories. La Stef has recorded most of Miss Ella's tunnel tour here for readers and viewers of *The Accidental Archives of the Royal Chicano Air Force*.

c/s

Ella Maria Diaz

NOTES

1. Sauer adds, "R&R actually did secede from the Union . . . I think for about three months. Until the 4th of July came around. At the time (and maybe still), it was the smallest republic in the world." Stephanie Sauer, email to author, April 14, 2014.

2. Stephanie Sauer, email to author, February 17, 2013.

3. After Terezita Romo finished her presentation on February 22, 2007, in the University Library Gallery at CSUS, she took questions from the audience. Pete Hernández identified himself and offered several insights into the history of LRGP. Romo also informed the audience that Hernández had been the "Chair of M.E.Ch.A" at the time and helped raise money to launch the Galería Posada in 1979 and 1980.

4. Hayden writes that when the Los Angeles Community Redevelopment Agency "realized that the site for the Broadway Spring Center included the historic site of the Mason homestead, they asked if it might be possible for The Power of Place to sponsor some kind of commemoration as part of the new development" (170–71).

5. Hayden's chapter on the Biddy Mason memorial is preceded by an excellent chapter on Biddy Mason's history, "The View from Grandma Mason's Place" (138–167).

6. This is a reference to Sauer's 2008 book with Esteban Villa, *The Noun Painter: Works by Esteban Villa, Mapped by Stephanie Sauer*.

7. Salvador Güereña, email message to author, February 22, 2010.

8. "About Calisphere," accessed March 19, 2013, http://www.calisphere.universityofcalifornia.edu/about-cs.html.

9. Sal Güereña explains that "in 1993, [the] scope of the archives program was expanded to include the four major ethnic groups in California, and the program adopted the name California Ethnic and Multicultural Archives, becoming an arm of the Department of Special Collections" (1988, 7). Güereña's article "Archives and Manuscripts" was first published in 1988 in the journal *Collection Building*. See also Salvador Güereña, "Archives and Manuscripts: Historical Antecedents to Contemporary Chicano Collections," *Alternative Library Literature, 1988/1989: A Biennial Anthology*, ed. Sanford Berman and James P. Danky (Jefferson, NC: McFarland & Co., 1990), 193–200.

10. The Chicano Youth Conference in Denver took place in March 1969 and the conference at Santa Barbara, California, followed in April.

11. The *Just Another Poster?* exhibit was hosted at the Jack S. Blanton Museum of Art at the University of Texas in Austin from June 2 to August 13, 2000. The show was exhibited at UC Santa Barbara's University Art Museum from January 13 through March 4, 2001. It was hosted at the Crocker Art Museum in Sacramento from June 20 until September 14, 2003. La Raza Galería Posada cosponsored this exhibition. For more information, please see the exhibition catalogue, *Just Another Poster? Chicano Graphic Arts in California* (2001).

12. Chon Noriega, "Postmodernism: Or Why This Is Just Another Poster." In *Just Another Poster? Chicano Graphic Arts in California*, ed. Chon Noriega.

13. Sheila O'Neill, email to author, October 1, 2009.

14. "A Celebration for the Opening of the Joe Serna, Jr. Papers," October 21, 2007, loose flyer handout, personal copy.

15. Sheila O'Neill, email to author, October 1, 2009.

16. True story.

WORKS CITED

Anzaldúa, Gloria. *Borderlands/La Frontera: The New Mestiza*, 2nd ed. (San Francisco: Aunt Lute Books, 1999).

Boone, Elizabeth Hill. *Stories in Red and Black: Pictorial Histories of the Aztecs and Mixtecs* (Austin: University of Texas Press, 2000).

de la Loza, Sandra. *The Pocho Research Society Field Guide to L.A.: Monuments and Murals of Erased and Invisible Histories* (Los Angeles: UCLA Chicano Studies Research Center Press, 2011).

Echevarría, Roberto González. "Cien años de soledad: The Novel as Myth and Archive," *MLN* 99, no. 2 (1984): 358–380.

Elam, Harry J., Jr. *Taking It to the Streets: The Social Protest Theater of Luis Valdez and Amiri Baraka* (Ann Arbor: University of Michigan Press, 1997).

Foucault, Michel. *The Archaeology of Knowledge and The Discourse on Language*, trans. A. M. Sheridan Smith (New York: Pantheon Books, 1972).

Grossman, Elizabeth G. "A Place for Everyone," *Women's Review of Books* 13, no. 2 (1995): 24–25.

Güereña, Salvador. "Archives and Manuscripts." *Collection Building* 8, no. 4 (1988): 3–11. http://www.library.ucsb.edu/special-collections/cema/archives_manuscripts (Accessed on April 19, 2014).

Hayden, Dolores. 1997. *The Power of Place: Urban Landscapes as Public History*, 2nd ed. (Cambridge, MA: MIT Press, 1997).

Lemon, David B. "Oral History Interview with Ricardo Favela." Conducted at California State University, Sacramento, November 6, 2001. Ethnic Survey File. Courtesy of the Sacramento Archives and Museum Collection Center.

Lipstiz, George. 2001. "Not Just Another Social Movement: Poster Art and the Movimiento Chicano." In *Just Another Poster: Chicano Graphic Arts in California*, exhibition catalog, ed. Chon A. Noriega (Santa Barbara: University Art Museum, University of California, 2001), 71–89.

Montoya, José. Interview by author, Sacramento, July 5, 2004.

Noriega, Chon A. 2001. "Postmodernism, or Why This Is Just Another Poster." In *Just Another Poster? Chicano Graphic Arts in California*, exhibition catalog, ed. Chon A. Noriega (Santa Barbara: University Art Museum, University of California, 2001), 20–23.

Romo, Terezita. "Points of Convergence: The Iconography of the Chicano Poster: A Collection of RCAF Posters and Contemporary Art." Lecture at University Library Gallery, California State University, Sacramento, February 27, 2007.

Santos, Philip. "Introduction." In *La Raza's Quinceañero*, La Raza Galería Posada (Sacramento: Tom's Printing, Inc., 1988), 1.

Sauer, Stephanie. *The Noun Painter: Works by Esteban Villa, Mapped by Stephanie Sauer.* (Sacramento: Copilot Press, 2008).

Valdez, Luis. *Aztlán: An Anthology of Mexican American Literature*, ed. Luis Valdez and Stan Steiner (New York: Vintage Books, 1972).

Villanueva, Tino. "Brief History of Bilingualism in Poetry." In *The Multilingual Anthology of American Literature*, ed. Mark Shell and Werner Sollors (New York: NYU Press, 2000), 693–710.

Weber, John Pitman. "Politics and Practice of Community Public Art: Whose Murals Get Saved?" Paper presented at "Mural Painting and Conservation in the Americas," Getty Research Institute and Getty Conservation Institute Symposium, May 16–17, 2003, http://www.getty.edu/conservation/publications_resources/pdf_publications/weber.pdf

THE ACCIDENTAL ARCHIVES OF

THE ROYAL CHICANO

AIR FORCE

A TRAVELING EXHIBITION

CURATED BY LA STEF

DEDICATED TO ALL
MEMBERS OF THE ROYAL
CHICANO AIR FORCE,
PAST AND PRESENT.

Painting has come to an end.
Who can do anything better
than this propeller? Can you?

MARCEL DUCHAMP,
upon viewing an RCAF adobe
airplane with ollín propulsion

It's on record. I'm not making
this stuff up.

GENERAL ESTEBAN VILLA

In doing this work, it has been
necessary to blaspheme two
cultural traditions: the written
word and the spoken word.
It is my hope that two acts of
sacrilege make a sacred.

LA STEF,
Lead Archivist

CAST

The majority of whose work goes unrecorded in official historical documentation of the Royal Chicano Airforce, including this very catalog, even despite the author's meticulous efforts and unbiased record-keeping practices.

JOAQUÍN MURRIETA MOCTEZUMA II

PANCHO VILLA JOSÉ CLEMENTE OROZCO ELVIA NAVA

JOSÉ GUADALUPE POSADA DOLORES HUERTA CORKY GONZALEZ ELI NUÑEZ

LAS ADELITAS NEZAHUALCOYOTL, THE NASTY COYOTE TERE ROMO MA

DAVID ALFARO SIQUEIROS CESAR CHAVEZ RUDOLFO "RUDY" CUELLAR LUPE POF

FRANK "THE FOX" GODINA RENE YÁÑEZ JUANISHI OROSCO JUAN CERVANTES JU

CARLOS LICÓN QUETZALCOATL ARMANDO CID LORRAINE GARCÍA-NAKATA

DIEGO RIVERA SEÑORA COBB RICARDO FAVELA JOSÉ MONTOYA JUAN CARRILI
ESTEBAN VILLA

FRIDA KALHO DR. ARNALDO SOLIS IRMA LERMA BARBOSA STAN PADILLA

MAYOR JOE SERNA, JR. CARLOS CORTEZ MAX GARCIA GIL

"LUIS THE FOOT" GONZALEZ SAMUEL QU

BERTOLT BRECHT FREDDY RODRIGUEZ & THE RCAF BAND PAT AGUIRRE HECT(

REIES LÓPEZ TIJERINA

SENÓN VALADEZ GRACIELA RAMÍREZ GLORIA "GLO" RANGEL SAM RIC

TIM QUINTERO TURTLE RODRIGUEZ ISABEL HERNANDEZ

BENNIE TRUJILLO RAULIE SUAREZ GED MARTIN ORALIA POLF

MIGUEL ESCOBEDO FREDDIE GONZALEZ CLARA CID FAST EI

JESSE ORTIZ-OCELOTL DANIEL DE LOS REYES

4

JENNIE BACA

CHUY ORTIZ & GRUPO XITLALLI PASCUAL MARQUEZ

SA RUBEN LERMA RUDY CARILLO HELEN TRUJILLO RUDY CARRILLO

AS RUDY MORONES RAULIE SUAREZ FAST FREDDIE SALAS ANDY PORRAS

IRENE FRIAS MANUEL CARO RICO HERNANDEZ ANGELO ALVAREZ

O MELINDA RASUL JOSÉ FELIX FRANCISCO J. GONZALEZ LUCY MONTOYA

O RICHARD RODRIGUEZ MANUELA SERNA ALBERT MESTAS JOE CAMACHO

AMANTEZ VICTOR OCHOA PETE HERNANDEZ RAMÓN ONTIVEROS ROGER VAIL

RERA RODRIGUEZ CARLOS "STUBBO" PORTILLO PATRICIA CARRILLO JOSÉ FELIPE MAGDALENO

OYA SALVADOR TORRES TONY LONG HAIR XAVIER TAFOYA BILL GEE

ROSEMARY RASUL HELLEN VILLA ANITA BARNES VICTOR HERNANDEZ

CLARA FAVELA RUBEN SERNA RICARDO MACIAS RICHARD MONTOYA

PHILIP "PIKE" SANTOS MICHEAL NEGRETE EVA GARCÍA PEDRO HERNANDEZ

RASUL JOSÉ LOTT FIDEL TRUJILLO ROSA HERNANDEZ JUAN GONZALEZ JUNIOR BACA

EEL" RANGEL KATY ROMO GLORIA GAMINO "MEXICO" CID MANUELA SERNA

ORIA TORRES MANUEL DIAZ XICO GONZÁLEZ MANUEL FERNANDO RIOS

JESUS BARRELA TOMÁS MONTOYA KATHERINE GARCÍA EVA SERNA

(All others, favor de sign here)

CONTENTS

A BRIEF INTRODUCTION TO THE ROYAL CHICANO AIR FORCE

RCAF: [\r · \c · \a · \f] orig. SacrAztlán 1: acronym of the Rebel Chicano Art Front 2: acronym inscribed in place of individual artists' names on numerous silkscreen posters announcing various causes, boycotts, and fiestas found throughout Aztlán, beginning in the year 1969 of the Christian calendar 3: acronym of the Royal Canadian Air Force 4: pertaining to a widespread confusion between the Rebel Chicano Art Front and the Royal Canadian Air Force, resulting in a subsequent name change of the former to the Royal Chicano Air Force 5: acronym of the Royal Chicano Air Force 6: Cesar Chavez's Air Force 7: an independent graphic arts wing of the United Farm Workers Union also employed to guard Cesar Chavez during speeches and pilgrimages in the greater Sacramento region 8: independent publishers in the silkscreen poster medium 9: an air force within which rank is fluid 10: referring to a close-knit group of pilots not at the exclusion of the larger troops that made up the organization of the Royal Chicano Air Force 11: media reference to "The Robin Hoods of the barrio" 12: ". . . a footnote in history" 13: founders of the Barrio Art Program, Breakfast for Niños, and La Raza Bookstore and Galería Posada 14: phenomenon of having international recognition while being ignored in country of origin

In 2002, Sacramento Magazine named the Royal Chicano Air Force the:

"Best Unknown World-Renowned Local Artists."

Fig. 1. La Stef, Index Note #1: Sacramento Magazine, 2011. 3" x 5".

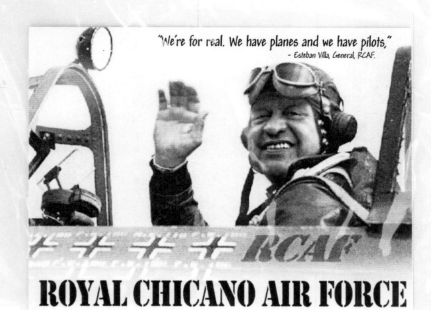

Fig. 2. Evidence Bag #1: RCAF postcard feat. General Confusion, 2009.
Postcard design © Rene Villa. Courtesy of Rene Villa and Esteban Villa.
4" × 5.5". Photo by Jesse Vasquez.

NOTES ON HISTORICAL DOCUMENTATION OF THE ROYAL CHICANO AIR FORCE

Fig. 3. La Stef, Founder of Con Sapos
Archaeological Collective, 2012.
Photo by Jon Alston.

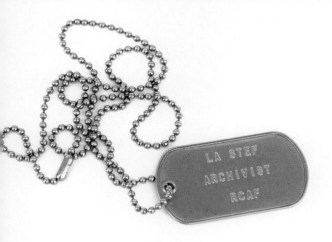

ARCHIVIST'S NOTE

Fig. 4. La Stef dog tag, 2008.
Photo by Jesse Vasquez.

I BEGAN the arduous task of documenting, preserving, restoring, organizing, collecting, categorizing, and cross-referencing the whole historical truth of the Royal Chicano Air Force (RCAF) several lifetimes ago when I was incarnated and initiated in a body much different from this current one. A body composed of small pores and broad hands. I was mute but not deaf and put to work as a keeper. I kept the adobe. I kept the secrets. We did not have writing, but I was born with memory then. I was born with seeing. Now I need evidence. I need documentation. I decided to continue with my work as an archivist in this current incarnation, to create entire libraries of proof. My hands are still calloused, but they are more delicate now, able to move through manila files and ephemera at a superhuman pace, able to document meticulously in red and black ink. My nails are still unkempt. I no longer guard the adobe—that task has been taken up by an appointed subcommittee of the Board of Directors, operating under 501(c)(3) status. I now share upkeep duties with the Impudent Young Pilots of the third and fourth generations—soon to be fifth, including biweekly dusting of all control panels in the aircraft fleet.

In Nahuatl, the word for history, ihtloca, literally translates to "what is said about someone or something."

Fig. 5. La Stef, Index Note #2:
Nahuatl for History, 2007. 3" × 5".

In this detailed account of the complete history of the RCAF, you will find original sources manufactured to resemble myth, careful New Historical analysis, and a collection of facts to lead you toward Truth. Because there is only one, as we all know.

La Stef
SacrAztlán, 2012

CON SAPOS is an archaeological collective over five hundred years in the making. Our mission is to record, collect, and preserve history in the Americas as it happens. Since the colonial period, our approach has been unique in combining techniques of preservation indigenous to this continent, as well as those introduced by European archivists.

We employ the advanced research tools and early ephemera tracking techniques developed by Terezita Romo and Josie Talamantez during their tenure as RCAF and SacrAztlán historians before and after the arrival of the Dog People. Among Con Sapos' noted contributions to the field are the recovery of lost and stolen RCAF materials, our detailed record keeping of events occurring throughout Aztlán before the Third Sun, and our pioneering applications of mitolosofía.

OUR TEAM

Con Sapos' current team is led by La Stef and Miss Ella, and an advisory board headed up by Quetzalcoatl. Active members of the field research team include John Rollin Ridge, Jean Charlot, Bertolt Brecht, José Vasconcelos, Erich von Däniken, Darcy Ribeiro, cartographer Miss Ella, and videographer Joaquín Calavera.

QUETZALCOATL pioneered the practice of *tlacuiloismo* (the historian's art) in the Americas. He currently acts as Advisory Board Chair for the Con Sapos Archaeological Society, and served during the Movimiento Chicano making regular guest appearances on El Teatro Campesino stage as The Evening Star.

LA STEF is a trained oral historian, anthropologist, and chismeologista, specializing in the mitolosofía of CalifAztlán. She is a founding member of Con Sapos Archaeological Collective and holds several PhDs in numerology, code breaking, and ancient languages from Margaret Mead University. She was recently awarded the International Culture VulTurismo Award for her work in uncovering the sacred scrolls of the Royal Chicano Air Force and has been quoted as saying, "History? It's all fiction."

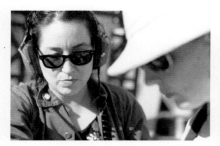

Fig. 6. Miss Ella, Lead Cartographer
of Con Sapos, 2012. Photo by Jon Alston.

Fig. 7. La Stef and Miss Ella in Old Town Sacramento, 2012.
Photo by Jon Alston.

MISS ELLA is a loco historian who knows a lot about the super groovy murals that the Royal Chicano Air Force painted in SacrAztlán. After a chance encounter with La Stef at Vallejo's Restaurant, she joined the ranks of Con Sapos, eventually becoming Lead Cartographer and RCAF Operations Specialist.

SERVICES

Beyond advancing the fields of archaeology, historiography, anthropology, code cracking, archival studies, and mitolosofía, Con Sapos offers numerous services to the community, including guided tours of historic RCAF sites. A favorite among locals is Miss Ella's Tunnel Mural Tours™ in which visitors learn how to read Chicano hieroglyphics and decode secret signs hidden throughout the mysterious L.A.S.E.R.I.U.M. murals in Sacramento, California.

THE GREAT libraries of Aztlán have not been preserved in methods approved by the Society of American Archivists, but in most cases by rasquache-ordained methods developed over a long period of suns.

WALL BOOKS

One such method involves the use of 35mm Kodak film and a sequence of bus fares to document the historical picture books published on walls and building interiors by artists sometimes, but not always, on commission. Sleek black boxes of slides and snapshot reproductions are all that remain of many of these early books, known as "murals." In other cases, there remains no physical record of these large-scale visual books, as is often the case in surprise censorship raids known colloquially as "whitewashing."

SERIGRAPHS AND THUMBTACKS

Even more advanced collection and preservation practices include ripping silkscreen posters off telephone poles and bus stop covers, displaying them in apartments and dormitories through the use of thumbtack mounting practices.

Fig. 9. Fiesta de Maíz sacred scroll. Photo by Jesse Vasquez.

Fig. 8. L.A.S.E.R.I.U.M. Mural (Detail, North Wall by Esteban Villa), 2012. Photo by Jon Alston.

Fig. 10. Untitled (Site of Armando Cid's missing "Sunburst" wall book), 2009.

ORAL VAULTS

Spoken accounts are the most elusive to any form of documentation, with many breaking down upon transcription. Or, as is often the case, the accounts simply refuse to be recorded at all. However, when the accounts remain spoken, they are among the richest sources known to the Con Sapos team.

MOVING SCROLLS

Exemplified by such scroll boxes as those recovered by La Stef and Miss Ella from Sacramento's Southside Park cenote are the preservation of ceremonies and other cultural happenings in the form of moving scroll documentaries. The precursor to film and modern-day television, these still images chronicled in scroll form preserve stories that might otherwise be lost to future generations. Hidden underwater in wooden boxes sealed with copal and piñon resins, the recovered scrolls retain their original content in pristine condition.

FILM

Other documentation methods, such as the collection produced and housed by Con Sapos videographer Samuel Quiñones, reflect decades of motion picture footage of ancient ceremonias and celebrations. This technology, however, requires continual updating to digital and as of yet unimagined media.

All works collected thus far and on view in galleries and cultural institutions today show evidence of early and unsanctioned archival techniques.

At the California State University, Sacramento archives, the finding aid for the RCAF poster collection is organized in alphabetical order by the names of each individual poster artist.

From the group's inception until 1975, the individual artists did not sign the posters except with the acronym of the collective.

Fig. 11. La Stef, Index Note #3: CSUS Archives, 2008. 3" x 5".

IN EVERY serious archivist there is a budding archaeologist, drawn to things so old that death has passed through them and made room for other lives. Sometimes they are in their fifth and sixth incarnations and unearth themselves.

I speak not only of my own obsessions, but of those of the entirety of Con Sapos, of course. We have taken it upon ourselves to restore and preserve those most sacred artifacts known and unknown to the RCAF, wherever it is we may find them—in the dumpster behind the Reno Club, in the digs held among Sacramento Concilio and the Chicano Organization for Political Awareness (COPA) administrative files, or in the layered soil samples of earth taken from throughout Aztlán.

Through cutting-edge dating practices developed by the Anasazi using lunar incubation methods in underground kivas, we at Con Sapos have identified flight patterns charted by ancient RCAF astronomers. We have concluded them to have been abandoned, along with entire settlements, during the First Sun. Through the generous permission of Reies López Tijerina and local area residents, we were able to search the records, preserved in acid-free fireproof adobe containers. Our team found them stored in the once-ceremonial kivas at a time of the mass exodus. Arranged in no linear order, the most notable characteristic of the collection was the repetition of accounts: scroll after scroll after codex contained records of the same events documented in a slightly different style by distinct hands. In the RCAF materials on file at the Pentagon, only one version of each history has been kept. All have been refiled in chronological order and marked with color-coded bars indicating their respective threat level to national security.

Other successful Con Sapos archaeological digs include a four-hundred-square-foot site in front of the Southside Park amphitheater in Sacramento, one square acre surrounding the Alkali Flat light rail station, various walls throughout the Sacramento State University campus, and several sites in and around the Franklin-Fruitridge area of the city, along with others located at carefully marked sites throughout Aztlán.

THE ARCHAEOLOGICAL PRACTICE

A NOTE FROM CON SAPOS REGARDING THE WRITTEN WORD

WHILE OUR contemporaries in the New European Americas were measuring the brain sizes of men and women of what were termed "different races" to prove various levels of superiority, and while their largest hurdle in freeing themselves to uncover scientific truths were the dates set forth by designated and well-paid interpreters of the Old Testament, our team had long taken leave of our reliance on the Good Book as it had not a place in these Américas until well into the aptly named Bronze Age, and even then with questionable impact. We instead turned our attention, long before radiocarbon dating, to a specialized technique developed by blending distilled Anasazi and Mayan astrological dating systems with vast references from the Oral Vaults.

It is worth noting also that after much scrutinizing and heated—if not intoxicated—debates, the members of Con Sapos, under the direction of our Board of Directors, eventually settled upon the unanimous conclusion that all written accounts, including the famed Aztec codices and royally commissioned Maya stone carvings, were not to be looked upon as sources of historical truth, but merely as fictional accounts that illuminated the messages the authors felt would pacify spectators and ensure their patrons' retention of power. Simply put, it is the official position of Con Sapos that the written word is little more than contextualized deception. We encourage readers to take this text as one such example.

Our organization does, however, recognize that there are those for whom text is the epitome of the sacred, a whisper from the holy spheres manifested in the physical plane. For those of such conviction, we invite you to savor the following documentary.

Fig. 12. La Stef, Index Note #4: Art History, 2007. 3" × 5".

Art historians have long known that Giorgio Vasari invented most of the stories he anthologizes in his seminal biography of Renaissance artists, "The Lives of the Most Excellent Painters, Sculptors, and Architects." Published in the mid-1500s, the work served as the foundation for modern art history. Contemporary Western ideas of art and artist are seeded in this work of fiction.

AN OVERVIEW OF ROYAL CHICANO AIR FORCE HISTORY

RCAF Prehistory

The Y'Pa'Que Tribe wandered the valleys of an unnamed continent, settling where they could for the time they were offered. They moved with the seasons, with the water supply, followed the food from the hunt.

They also had morphing qualities- the ability to shape shift. Theirs was the hummingbird for it crossed the borders of life and death, vida y sueno. As the tribe traveled, the humming-birds followed them, watch-ing over. Tribe members fashioned feeders out of hollow gourds and filled them with blood. Some say it was because they ___ th___

Fig. 13. La Stef, RCAF Prehistory, 2007.

A BRIEF AND ACCURATE HISTORY OF RCAF AVIATION

ALBERTO SANTOS DUMONT,* known as "Little Santos" or "Le Petit," was a wealthy Brazilian, impeccable in dress, who moved to Paris with plans to create the "First Volkswagen of the Air." In 1898, at the age of twenty-five, he piloted his first aircraft. His greatest achievement, however, came several years later in the form of Santos *No. 20* or *Demoiselle* (Dragonfly). A monoplane made of bamboo, linen, and wire with a wingspan of sixteen feet and five inches, it flew as the smallest and lightest aircraft in the world. In one trial, Santos Dumont had run short of linen and used instead several napkins from a bar near his rented flat, soon finding that

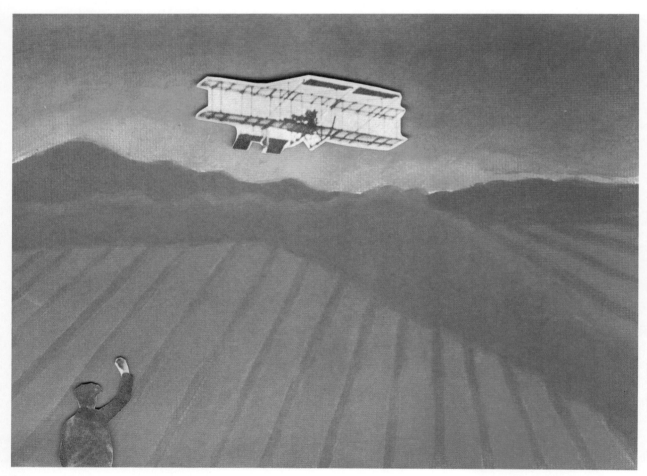

Fig. 14. Inaugural Flight of LaRuca 2012. With permission of use of Los Files © Juanishi V. Orosco. Courtesy of Juanishi V. Orosco.

* Aeronautical pioneer for whom Rio de Janiero Municipal Airport is named.

José Montoya had sketched upon them and forgotten to take them home. The engineer considered them the perfect accent to his everyman's flying machine. All the sleek yet robust design needed was color, so the fashionable Santos hired the mysterious Carlos Licón.

Being accustomed to painting on whatever lay at hand, including newspaper, Licón quickly took to painting the remaining linen coverings of the Demoiselle. Licón quickly realized his true calling and turned his aircraft work over to Rudy Cuellar, who was a natural mechanic and whose love for fireworks threatened the linen preferred by the delicate Brazilian. Thus, in an effort to avoid the treacherous effects of Cuellar's pyrotechnics, the rest of the RCAF set out in experimentation with various materials close at hand. After attempting Santos' model using maguey fibers, black oak, and jade for which they traded with artesanos in Oaxaca, the young pilots finally came across adobe, a naturally occurring compound that could be molded and shaped into their desired form. The use of adobe, however, made the aircraft heavier than Santos Dumont's original construction. So, under the direction of Señora Cobb, Dr. Arnaldo Solís, and Stan Padilla, they created a ceremonia in which the heavy mass could be lifted into flight with the help of Juan Cervantes' combustible engine research for prolonged suspension.

The foundation check the pilots received for research was placed into the hands of Executive Director Max Garcia. After a comprehensive celebration of the project's funding, the $40,000 check was found in the dumpster the next morning by a local prostitute whom they had befriended months earlier. She returned the check to headquarters. Max Garcia was relieved of his financial oversight responsibilities.

When all preparations were finally complete, the pilots held a test run from Sacras to Woodland, where La Ruca 2012 crashed into the back of a semi full of bailed alfalfa. A preliminary assessment of the problem by the astute members of Chicano Organization for Political Awareness, led by the future mayor Joe Serna, Jr. and housed in the corner of the first RCAF headquarters, found the frame intact. Their official report

Fig. 15. Con Sapos Expedition Luggage Tag, 2011. From the collection of La Stef.

Fig. 16. RCAF Evidence Bag: Adobe
airplane. From the collection of
Con Sapos.

At Simon's Bar on 16th Street
across from Luna's Cafe, the
balding man with bright blue eyes
asks if Ishi knew that the adobe
airplanes made Pablo Neruda laugh.

Francisco Something had told the
balding man this.

Fig. 17. La Stef, Index Note #5: At Simon's Bar, 2005. 3" × 5".

Fig. 18. *Residencia de Santos Dumont plaque*, 2009. Santos Dumont Museum: Petrópolis, Rio de Janeiro, Brazil.

was typewritten on legal paper and offered suggestions for improvement, including: the use of maguey fronds for propellers; wheels of gessoed masa de maíz (upon which it is said that Montoya's tortilla art first originated); sharpened obsidian for a more aerodynamic tail fin; safety equipment that would convert the craft into a floating chinampa upon collision; and a reinforced frame using yucca roots from San Diego's Chicano Park (select harvest was facilitated through connections of forward-thinking pilot Josie Talamantez).

COPA's suggestions were implemented, and Rudy Cuellar and Louie "The Foot" equipped the fleet with hand-operated mimeograph machines and small silkscreen operations, since they required no electricity or unnecessary gadgets, only silk mesh, ink, frames, and squeegees. Licón agreed to christen the refined craft by painting the windshield.

ANATOMY
OF AN ADOBE
AIRPLANE

Propellers:
 Maguey fronds

Wheels:
 Tortillas

Ailerons:
 Piñon

Fuselage:
 Adobe

Paint:
 Carlos Licón, using Col. José Montoya's mother's recipe for
 blue paint made from the tails of horseflies.

Engine:
 Liquid-cooled radial (7-point)
 Elkpower: 507
 Bore and Stroke: 3.8 in × 3.2 in
 Displacement: 354

Fuel:
 Maize syrup
 Agave nectar for maximum performance

Navigational Method:
 Single string tied to wing

Insignia:
 Huelga Eagle

Inscription:
 La locura lo cura

Fig. 19. Juanishi V. Orosco, Adobe Airplane, 2009. Photo
by Jesse Vasquez. From the collection of Con Sapos.

HOW TO BUILD AN ADOBE AIRPLANE

MATERIALS

bucket
mud
sand
water
copal

MAKE A mixture of approximately nine buckets of fine-grain mud and three buckets of sand. Mix together. Add water to make a paste. Play with the mixture until you can make a ball that will stick together and not crack. Tightly shape the mud mixture into your chosen form of airplane. Move the mold to a sunny place and let the mixture dry in the sun for seven or more days. Christen with copal and song. Do not forget to make your offering to Tlaloc.

BRIEF HISTORICAL OVERVIEW

The origins of the Adobe Airplane date back to the days of Los Brothers Cuecueyah during the Third Sun. Los Cuecueyah were from a long line of adobe shapers who later traded their skills with Los Zuñi and Hopi of the north. On their first flight attempt, they soared from the top of the Templo Mayor in present-day Mexico City straight into the main zócalo, maiming fourteen merchants and only three turkeys.

Comandante Montoya, being from an area of New Mexico long influenced by Los Zuñi, brought the ancient practices of adobe plane building to SacrAztlán. However, the Comandante was more skilled as an adobe painter than engineer. Fortunately, RCAF pilot Rudy Cuellar is said to be a descendent of Los Brothers Cuecueyah and a pair of Chinese mariners who smuggled fireworks into Teotihuacán near the end of the Third Sun, and has since made important contributions to the field of RCAF aeronautics.

Self-taught airplane engineer Gilbert Gamino eventually came on board and opened Aeronaves de Aztlán mechanical cooperative to service all crafts in the RCAF fleet free of charge. He even serviced Cesar Chavez's refurbished craft when the union leader came to town to conduct top-secret negotiations with members of the Air Force.

Headquarters:
 Fresno, California
Admiral:
 Ernie Palomino
Navigation:
 Neon lights salvaged from the Reno Club
 The Evening Star, who doubled as Quetzalcoatl for the fulfillment
of certain creation myths.

BRIEF HISTORICAL OVERVIEW

Anáhuac, "the place by the waters," served as the first training base for the Royal Chicano Navy. It later became México-Tenochtitlán when RCAF troops in El Norte told the Dog People of their operation. The Navy relocated to Fresno upon hearing that José de la Cruz Porfirio Díaz Mori was reelected to the presidency after the controversial campaigning of 1884. The Air Force welcomed the fleets, insisting they should have returned to the valley sooner.

This all happened when California was still an island.

Fig. 20. La Stef, Royal Chicano Naval Fleet, 2008.

ANATOMY OF A ROYAL CHICANO NAVAL SHIP

Main mast:
 Banana-shaped hulls of ocotillo cactus from Baja, California, and tortora reeds smuggled down from the Andes Mountains by runners on an elaborate dirt highway system from which present-day Los Angeles sprung.

Battened Sails:
 Recycled huipils and reinforced red cotton squares that double as the material Privates Louie "The Foot" and Rudy Cuellar use to silkscreen Huelga flags for United Farm Worker Union marches, work for which they receive little notice.*

Rudder:
 Valley oak carved by Sal Yñeguez at Del Monte Studios

Charts:
 Supple quetzal bones bent to land mass contours
 Wind movements fired onto pottery

Anchor:
 Obsidian

Steering Wheel:
 Direct appropriation from Spanish galleons

Artillery:
 Buckeyes (unsuspecting, for easy transport across borders)

* The origin of the Huelga Eagle's design is contested, but at least two accounts, including his own, credit Ricardo Favela, que descanse en paz.

ORAL ACCOUNTS hold that the first fleet of Eagle Knight Warrior Pilots was represented by a stylized symbol of their maguey propellers (below). The propellers, as recorded here, thus became the universal Nahuatl symbol of Ollín, or Movement. As one can see clearly, the original shape has been modified for more aerodynamic movement in order to achieve maximum velocity. Its development has progressed over the shift from the Third to Fourth Worlds, leaving us with the economical yet efficient double propeller.

ORIGIN OF THE SYMBOL OF OLLÍN

Fig. 21. Ollín symbol. Artist unknown.

EARLY RCAF CARTOGRAPHY

THESE IMAGES depict wind movements charted by Casa Grande pottery artists on various vessels traded with Royal Chicano Air and Naval Forces. The mapped vessels not only allowed for the storage of spirits, dried grains, and jerked meats, but acted as discreet means of carrying out top-secret missions. Yankees later took up the ancient art of graphing, thanks in part to illegal reprinting of the designs by university archaeologists. These images were later transferred as flattened digital files and reproduced on cheap paper that could be bound by machine and used for military training.

The RCAF's top lawyer, The Fox, is currently developing a lawsuit against the United States Armed Forces in an attempt to recuperate all acquisitions made by violating the copyright protections of the stylized charts in a worldwide tribunal of indigenous nations.

Fig. 22. Untitled (wind movement charts), 2011. Photo by La Stef.

Facing. Fig. 23. Untitled (flattened reproduction of RCAF wind movement charts), date unknown. Source: Technical Manual—Weather Manual for Pilots. Washington, DC: War Department, 1940.

EARLY ROYAL CHICANO AIR FORCE MAKES AND MODELS

LA ESPINA DEL MAGUEY

One of the RCAF's earliest fighter planes, used primarily for covert United Farm Worker offenses, was aptly named La Espina del Maguey for its extreme aerodynamic frame which extended from a .05 centimeter frontal width to 48' rear jets.

Inside, Juanita Polendo Ontiveros housed the sewing machines used to make huelga flags at a moment's notice. She is said to have raided cornfields when maíz was in season in order to feed striking farmworkers.

THE POWERED SQUEEGEE

Designed and flown by Captain Louie "The Foot" González, the Powered Squeegee is the most elusive plane in the entire RCAF fleet. It was crafted primarily to serve as an undercover graphics operation for huelga posters for UFW strikes, including those that urged consumers to boycott grapes and Safeway markets until equitable terms for farmworkers could be agreed upon. For the design, González had worked from an original blueprint found among the José Guadalupe Posada papers smuggled up to San Diego by Arsacio Vanegas, grandson of Posada's illustrious employer, who found the printmaker's priceless works grossly undervalued by Mexican authorities [see Flight Logs].

Fig. 24. La Espina del Maguey, 1969. From the Permanent Collection of the Con Sapos Nationalist Museum.

Fig. 25. The Powered Squeegee, 1971.
From the Permanent Collection of the
Con Sapos Nationalist Museum.

Captain Foot adapted Posada's original drawings, trading out the block cuts for lighter, more aerodynamic wood frames, which he had skillfully mastered while working in Sal Yñeguez's shop, Del Monte Studios. He replaced the masking tape with hinge clamps and added screens made of coarse silk. While "The Foot" never saw the use of overhead pulleys for counterbalance when printing posters midflight, he let his fascination with squeegees take over in designing the craft. Using leftover squeegees from poster runs created upon demand for the union, he separated the wooden slats from their rubber belting, for which the artist had originally bartered with a small band of independent rubber farmers in Brazil who were later recognized as leaders of the Tropicalism Movement. The Captain had chosen their outfit on account of their environmental sustainability practices, referred to then as extremist activism. Thus, having once manufactured the squeegees himself from the imported source materials, "The Foot" found it even easier to take them apart. He then proceeded to weld the rubber parts together again in a form that would serve as a durable, waterproof exterior, which was of great concern for the master printmaker. Naturally, however, the artist found the dull gray finish unbearable. It is said that, due to his insistence to "paint it bold" late one night in his hangar, Louie "The Foot" came upon what was to become his famous "squeegee art."

As art historian Terezita Romo once noted, "The Foot" preferred the sleek design and sensual motion dictated by the two-handed squeegee. He found the form of his leftover handles ideal for a rich, earthen interior and stacked each retired wood holder on top of another until they lined the cabin with a geometric pattern in rippled oak. All this while listening to acid jazz over the radio.

THE ASTROCERAMIC JET

The astroceramic jet is the latest development in the Royal Chicano Air Force fleet. Commissioned by a trust established by Nezahuacoyotl's Third Pleasure House, research for the jet was conducted by Dr. Sam Ríos and a team of fourth-generation pilots in the shed behind Major Montoya's house. Previously, sweats were held in the same 16' × 24' shed, but it had since become an untapped resource. While the shed was deemed unfit for storing artwork in the extreme Sacramento heat, excess paints and watercolors as well as a small black-and-white television set are currently housed in the basement of said residence.

Plans for the jet all failed. The crew, directed by the unassuming Dr. Ríos, drew up several sets of blueprints with detailed hypotheses for each trial according to engine model and make, only to find that not one of the fifty-three attempts functioned according to plan. Exhausted and out of paper, the team called upon the expertise and insights of General Esteban Villa, skilled at the art of improvisational flight as he is. Right away, General Villa spotted the problem: planning. "You did the blueprints. Now burn them. Give them here, I'll light them for you."

The engineers handed them over with little hesitation, as they had already wasted every last ounce of their stubbornness in the trials.*

"Now, no mas ázlo." Sage advice for which the commission had earmarked a hefty sum as "consultation fees." With that, the General picked up his two 4" × 6" drawing pads, rubber-banded them together, and waltzed out the shed door.

* It is rumored that I was among them, though I cannot say for sure.

So, how did our brilliant engineers go from General Villa's simple advice to creating a state-of-the-art aircraft? They went for happy hour and, in stumbling through a conversation about who makes the best menudo, someone drew upon a condensation-soaked napkin an image of prime honeycomb tripe to illustrate their assertion. In the blurring that occurred laid their answer: minuscule air pockets to increase buoyancy and ease propeller strain. All agreed it was the solution for which they were searching and toasted the General, who was completely unaware of their revelation as he watched a live feed of the basketball game at Arco Arena.

Today, archaeologists agree that
the richest source for uncovering
the truth about ancient peoples
is their trash.

Fig. 26. La Stef, Index Note #6: Trash, 2004. 3" × 5". From the collection of the Con Sapos Preservationists Society.

Postscript: The team has since completed a new solar- and star-powered model, which harvests and stores the free-floating energy molecules for fuel use. Its outer layer consists of heat-resistant bricks made of sand, the discovery of which had partially inspired Europe's eventual conquest of the African and American continents as it had no deserts of its own. In preparation for their eventual residence on the planet Mars, the adventurous conquistadors pursued mineral rights of all desert lands as a vital goal of their exploits.

RCAF MURALS AT CHICANO PARK

A Security Façade?

Fig. 27. La Mujer Cósmica (detail).
© Esteban Villa. Courtesy of Esteban
Villa. Photo by La Stef, 2008.

CONSTRUCTED BETWEEN 1967 and 1969, San Diego's Coronado Bridge spans 2.1 miles, covering Barrio Logan with a "concrete canopy supported by a 'forest' of gray pylons."* The pylons supporting the bridge, which protects a US Naval Destroyer Base located at the actual site of Cabrillo's 1542 landing,** were designed by architect Robert Mosher with input from Royal Chicano Air Force Platoon Leader Josie Talamantez to float out into the ocean upon detonation, allowing Royal Chicano Naval Forces to navigate through the bay without being trapped by piled debris. Private Talamantez, who was stationed in San Diego, had worked on behalf of the RCAF to secure safe port for its aeronautical and naval fleets. Subsequently, she served on the community steering committee for the Chicano Park takeover in 1970, which culminated in a twelve-day occupation by the Chicano Federation. Having succeeded in reclaiming the land for community use, organizers began revitalization efforts, including the sowing of maguey and nopal plants, as well as the construction of a controversial indigenous-styled kiosko in the center for performances and events. Organizers led by Salvador Torres also envisioned magnificent murals on the plain column façades and raised enough funds to purchase the muriatic acid, rubber surface conditioner, and paints necessary to begin. Finally they invited artists from across the country, including RCAF pilots, to lay down color. The RCAF completed their panels in five days in 1975, embedding cartographic codes inside the elaborate designs so that, if detonated, those pieces scattered to the ocean could steer their readied naval forces (this as opposed to keeping all coordinates in one vulnerable position).

Recognized as the only open-air museum in the Americas, Chicano Park is currently being considered for designation as a National Treasure, thanks in part to the ongoing efforts of the RCAF's own Private Talamantez. As of yet, no art historians or national security agents have been successful in cracking the embedded cartographic code.

Chicano Park mural restoration efforts have been ongoing since 1984, with recent efforts culminating in a total revitalization by the year 2012, just in time for what is said to be the end of the Fourth World. While

* Wikipedia entry

** The city's "Historical Site" was moved to a stretch of paved walkway and flush toilets across from the Sheraton Marina.

calendric scholars argue that this date is miscalculated and that the actual end of the world occurred several Gregorian years back, it is a precaution the restoration committee took nonetheless to secure outside funding.

According to a Wikipedia entry, "a 2003 plan to renovate the park was stalled when Caltrans objected to the word 'Aztlán,' which for years had been spelled out in rocks on the park's grounds. Calling the term 'militant,' they claimed that using federal funding for the project would violate Title VI of the Civil Rights Act of 1964 by showing preference to Mexicans and Mexican Americans." Luckily for the park, Caltrans district director Pedro Orso, along with civil rights experts, determined that the controversial term was not in violation of any law. The grant of $600,000 was approved and restorations are currently under way.

The Nixon Administration, with help from Chilean and Argentine officials, tried to manage the militancy of Chicanos and Puerto Ricans by reminding them that their last names are Spanish, thus coining the term "HiSpanic".

Fig. 28. La Stef, Index Note #7:
HiSpanic, 2003. 3" × 5".

THE TWICE-HIDDEN TRUTH ABOUT RCAF SILKSCREEN OPERATIONS

THE PENTAGON'S declassification of Royal Chicano Air Force records have revealed the ulterior—and perhaps original—reason for the Force's preference of serigraphy over all other methods of communication: their screens doubled as templates for sending and deciphering encrypted messages to and from the United Farm Workers Union headquarters. By this method, they were able to send and receive through the United States Postal Service letters that looked normal, but that relayed top-secret messages when one lay a particular screen with its stenciled relief over the top of the page and read only the text inside the design. Poets were employed with the task of composing such letters, as their careful attention to language was vital in encrypting an economic yet sensible message, while at the same time making the broader letter appear believable as a regular correspondence—a necessary layering, since they knew all correspondences would pass through several Secret Service officers for inspection.

The much used "Huelga Eagle" symbol was a favorite silkscreen encryption template, as poets found it the perfect size to deliver a concise communication, and the visual aspect of the insignia itself was quick to inspire troops and pass unnoticed by postal workers. Also, in cases of surprise inspection by Secret Service agents, the screens themselves could be easily attributed to the making of huelga flags.

Generals Montoya and Villa conducted
their earliest flight maneuvers near
Berkeley, California under the name
Mexican-American Liberation Art Front -
what poet Alurista referred to as
La Mala F.

Fig. 29. La Stef, Index Note #8: La Mala F, 2003. 3" × 5".

THE FOUND CODEX

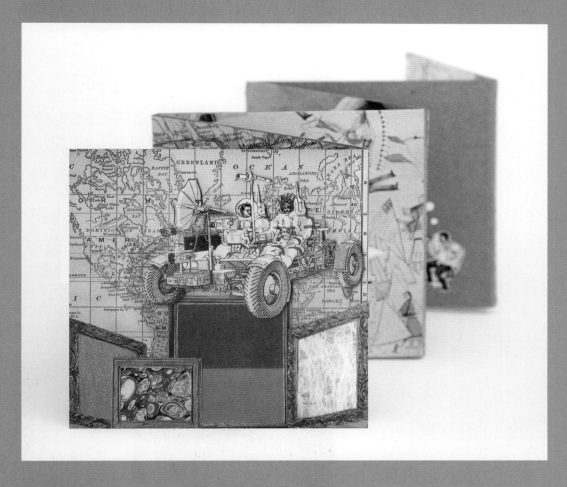

Fig. 30. Found Codex: CA—NYC
(full view), 2009. 5.5" × 35".
Photo by Jesse Vasquez.

THANKS to the meticulous glyph-deciphering efforts of Steve La-Rosa and the Con Sapos team, these codices have been translated into a (somewhat) linear, English-language narrative. This particular codex relates a narrative about José Montoya and Esteban Villa, cofounders of the Royal Chicano Air Force. Traditionally read from right to left, the numbered text blocks relate what has been inscribed in the corresponding panel:

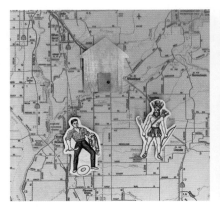

1. José Montoya[1] held a party at his home in Wheatland, California, to which he invited Esteban Villa.[2] While they were discussing their mutual dream of visiting New York City, the beer ran low.

Fig. 31. Found Codex: CA—NYC (panel 1), 2009. 5.5" × 5.5".

2. While out on a beer run, José y Esteban decided to leave for New York City right then.[3]

Fig. 32. Found Codex: CA—NYC (panel 2), 2009. 5.5" × 5.5".

3. Somewhere in Wyoming, their plane gave out.

Fig. 33. Found Codex: CA—NYC (panel 3), 2009. 5.5" × 5.5". With use of a sketch by Frederic Remington (1861–1909).

4. Hitchhiking, they made their way across the plains.

Fig. 34. Found Codex: CA—NYC (panel 4), 2009. 5.5" × 5.5". With use of Little Big Horn battle scene painted by Kicking Bear (1846-1904).

1. Whom other records show was a recent graduate of the California College of Arts and Crafts and art instructor at the time.

2. Also a recent graduate of CCAC turned art instructor, he was known as El Indio.

3. Oral records reveal that their initial departure plans, with transportation provided by a fellow partygoer, fell through due to said fellow's wife's disapproval. Villa and José immediately purchased said transportation device—their first aircraft carrier—from the retained party for the price of two original paintings.

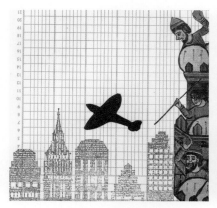

5. Eventually they arrived in New York City.

Fig. 35. Found Codex: CA—NYC (panel 5), 2009. 5.5" × 5.5".

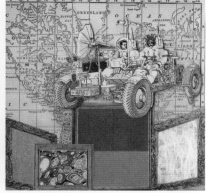

6. Proposed translation: "Well, we decided we're gonna go to New York and find Jasper Johns and all those crazy people that we had read about, [who] were our heroes . . . We never saw Jasper Johns or Motherwell or any of them, but we had a great time."

Fig. 36. Found Codex: CA—NYC (panel 6), 2009. 5.5" × 5.5".

7. José y El Indio got stuck in New York City. An old friend of José's from Berkeley had to wire them money for a voyage to New Haven, Connecticut.

Fig. 37. Found Codex: CA—NYC (panel 7), 2009. 5.5" × 5.5".

8. In New Haven, they arrive at the home of the man's aristocratic family.[4]

Fig. 38. Found Codex: CA—NYC (panel 8), 2009. 5.5" × 5.5".

4. José later recalled the rules: one had to dress for dinner and there was no fraternizing with the hired help.

9. On their return home, the two hitched a ride with an Amish cart driver in Pennsylvania who wanted to know "what they were and where they were from—especially Villa."

Fig. 39. Found Codex: CA—NYC
(panel 9), 2009. 5.5" × 5.5".

10. They fraternized with hill folk in the Ozarks.[5]

Fig. 40. Found Codex: CA—NYC
(panel 10), 2009. 5.5" × 5.5".

11. They hitched a ride across the Great Lakes.

Fig. 41. Found Codex: CA—NYC
(panel 11), 2009. 5.5" × 5.5".

12. And crash landed back in Wheatland.[6]

Fig. 42. Found Codex: CA—NYC
(panel 12), 2009. 5.5" × 5.5".

5. "They were real curious about us."
6. Records show that both José and Villa were subsequently divorced by their respective wives.

THE OMITTED PANEL

Omitted from the original commissioned codex, panel 4.5 contains the following event description (as translated):

> While hitchhiking through the Midwest, an Ohio mobster picked them up upon seeing their guitars. He had been looking for "troubadours" to play ballads at his boss's private dinner that night. Villa turned to José and asked: "What's a ballad?" They played a set and were sent away with a $100 bill.[7]

7. "I don't think they liked racheras or corridos."

FLIGHT MANEUVERS

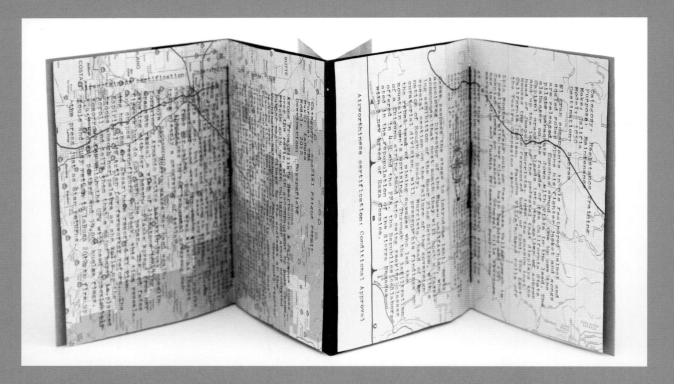

Fig. 43. RCAF Flight Log #1, 2008.
6.25" × 19.75". Photo by Jesse Vasquez.

THE FLIGHT logs of the Royal Chicano Air Force were originally recorded by unidentified pilots-in-training whose required duty it was to act as scribes on their first few runs. This is an example of the RCAF's philosophy that all members must be prepared and willing to perform any and all duties necessary to keep the squadron in operation. Keeping in the tradition of only inscribing ephemera with the collective's insignia, these flight logs are unsigned by their individual authors.

The multiple-tier codex fold and linen pamphlet stitch is typical of the RCAF's legacy of blended practice, which extends to these meticulously kept transcriptions. Drawing upon various book, map, and paper-making techniques, their logs give detailed accounts of once top-secret missions. Thanks to a generous grant from the Maguey Growers Federation of Las Americas, these rare artifacts have been transcribed and are now made available for public display.

Category: Special Flight Permit
Purpose: TBA
Make: LaRuca
Model: 2012
Destination: Bakersfield

A song from Villa's *Heartaches and Jalapeños* comes over the radio, with accompaniment by Buck Owens. Pilots suit up with bulletproof armor crocheted from maguey fibers by the ancianas at the Washington Neighborhood Center. They pull fighter jackets over these to add bulk.

Stan Padilla, who is customarily sent on beer runs during all-night vigils, embarks on a solo mission to retrieve piñon resin from his supplier across la frontera into Yaqui territory from where his family was expelled. Comandante Montoya had long disapproved of the use of ceremonial paraphernalia in RCAF missions after residing in Berkeley in the 1960s, but with Stan's commitment to cosmic interventions paired with Ishi's unassuming embrace of the Aquarian Age and the dawning of the Fifth Sun, the Comandante's resistance eventually gave way and he himself became an elder of the Círculo retreats for vatos of various generations. He even admits partaking in regular sweats.

Troops unload into Villa's old dive where Dolores Huerta awaits them at the bar, tossing back shots of agua ardiente with no grimace at all. She tells them Cesar has sent her, but everyone knows better. She signals them to a back room. She tells them to sit. Villa takes out his four-by-five-inch pad and Prismacolor Four-In-One markers and begins to sketch. She unrolls a map, but no one sees anything on it. Huerta waves her hand over the amate scroll and sparks drop from her palms. Rudy's eyes widen as images shape themselves in red ink until everyone can trace clearly the geography of Aztlán.

Montoya nods. Huerta waves her hand again and this time Lorraine and Armando notice her skin break open in several areas to reveal slabs of limestone exhaling, inhaling with her speech. Flames spread from her

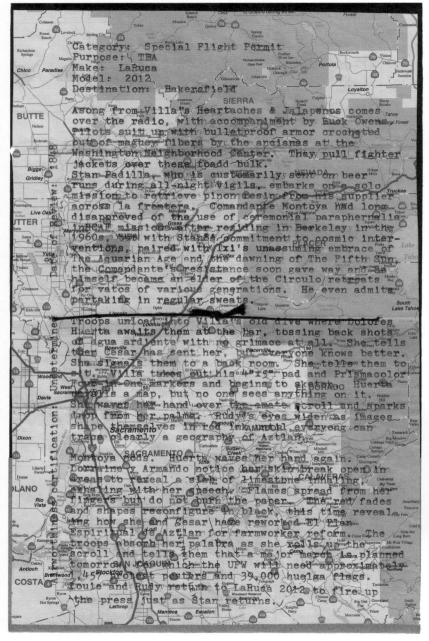

Category: Special Flight Permit
Purpose: TEA
Make: LaRuca
Model: 2012
Destination: Bakersfield

A song from Villa's Heartaches & Jalapeños comes over the radio, with accompaniment by Buck Owens. Vatos suit up with bulletproof armor crocheted out of maguey fibers by the ancianas at the Washington Neighborhood Center. They pull fighter jackets over these toadd bulk. Stan Padilla who is customarily sent on beer runs during all-night vigils, embarks on a solo mission to retrieve piñon resin from his supplier across la frontera. Comandante Montoya had long disapproved of the use of ceremonial paraphernalia in RCAF missions. After residing in Berkeley in the 1960s, Villa with Stan's commitment to cosmic interventions, paired with Ixi's unassuming embrace of The Aquarian Age and the dawning of The Fifth Sun, the Comandante's resistance soon gave way and he himself became an elder of the Circulo retreats for vatos of various generations. He even admits partaking in regular sweats.

Troops unload into Villa's old dive where Dolores Huerta awaits them at the bar, tossing back shots of agua ardiente with no grimace at all. She tells them Cesar has sent her, but everyone knows better. She signals them to a back room. She tells them to sit. Villa takes out his 4"x5" pad and Prismacolor two-in-one markers and begins to sketch. Huerta unfurls a map, but no one sees anything on it. She waves her hand over the ornate scroll and sparks drop from her palms. Rudy's eyes widen. Images shape themselves in red ink until everyone can trace clearly a geography of Aztlán.

Montoya nods. Huerta waves her hand again. Lorraine y Armando notice hairline break open in areas to reveal a sliver of limestone inking. She, shaking with her speech. Flames spread from her fingers but do not burn the paper. The red fades and shapes reconfigure in black, this time revealing how she and Cesar have reworked El Plan Espiritual de Aztlán for farmworker reform. The troops absorb her palabra as she rolls up the scroll and tells them that a major march planned tomorrow for which the UFW will need approximately 45,000 protest posters and 39,000 huelga flags. Louie and Rudy return to LaRuca 2012 to fire up the press just as Stan returns.

Fig. 44. RCAF Flight Log: Sacras—
Bakersfield, 2008. 6" × 9.5".

Fig. 45. RCAF Evidence Bag: Heartaches and Jalapeños. © Esteban Villa. Courtesy of Esteban Villa. Photo by Jesse Vasquez.

Fig. 46. La Stef, Wild Ishi, 2005. With permission from Juanishi V. Orosco.

fingers but do not burn the paper. The red fades and shapes reconfigure in black, this time revealing how she and Cesar have reworked El Plán Espiritual de Aztlán for farmworker reform. The troops absorb her palabra as she rolls up the scroll and tells them that a major march is planned tomorrow, for which they will need approximately 1,457 protest posters and 39,000 huelga flags. Louie and Rudy return to La Ruca 2012 to fire up the press just as Stan returns.

Fig. 47. RCAF Evidence Bag: piñon resin, 2009. Photo by Jesse Vasquez.

The holes in the corners of silkscreen poster made during the Movimiento do not lower their monetary or art historical value.

The RCAF sees these holes as part of the poster.

Fig. 48. La Stef, Index Note #10: Holes in RCAF Posters, 2011. 3" × 5".

FLIGHT LOG

Fowler–Las Vegas

Depart: Delano; Destination: Fowler
Comandante José Vasconcelos
All Pilots on Board

José Vasconcelos flies through the night and finds a landing strip in the middle of the desert with Carlos Castaneda in the control room, who charges the RCAF three serigraphs, one private recitation of [Louie The Foot's] "Cortéz Nos Chingó," medio-ounce of peyote y un handful of Louie's ginger candies.

The troops stay the night in the barracks and prepare to fly the next morning upon fueling up. They are scheduled to arrive at local area high schools for presentations, readings, lectures, workshops. Armando Cid has modified La Ruca 2012 to accommodate their traveling performance schedule by installing a rear exit that is codified to open upon Montoya's voice command. However, during this particular mission, Montoya had been attacked by El Mal Ojo, o quizas a cold, causing a general collapse of his vocal chords. Thus, unable to de-board the aircraft, the troops call Juanita [Polendo Ontiveros] to task. Wool satchel in hand, she arrives at José's bedside and, singing, withdraws three tea bags she had picked up at the 7-Eleven back in Carson City. She heats water in an old paint can over the engine and takes out a dense root harvested from Ramón's maguey patch. She drills into it with a Phillips-head, releasing the sweet fluids into José's sacred abalone—still stained from years of copal and coal. With this, she mixes a smidgen of bathtub whiskey smuggled in from Rough and Ready and the strong 7-Eleven infusion. As it cools, she molds a pastille in her palms and commands José to take it, to hold it. To suck.

The vapors form blue bodies that sing in the Comandante's ears. They press the sticky pads of their translucent fingers into his temples until he falls into a half sleep. Juanita breathes onto the Phillips-head and wipes it clean. She steadies it over his bare chest and twirls the handle between her palms until there is smoke. Until there is heat. Enough to penetrate his flesh. She plunges it into the heart until its beating vibrates up her arms. She removes her right hand from the handle and grabs the silkscreen

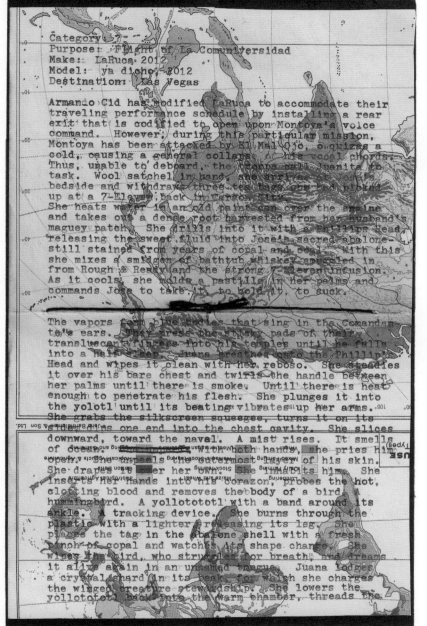

Category:
Purpose: Flight of La Comunidversidad
Make: LaRuca 2012
Model: ya dicho, 2012
Destination: Las Vegas

Armando Cid has modified LaRuca to accommodate their
traveling performance schedule by installing a rear
exit that is codified to open upon Montoya's voice
command. However, during this particular mission,
Montoya has been attacked by El Mal Ojo, o quizás a
cold, causing a general collapse of his vocal chords.
Thus, unable to deboard, the troops call Juanita to
task. Wool satchel in hand, she arrives at his
bedside and withdraws three tea bags she had picked
up at a 7-Eleven back in Carson City.
She heats water in an old paint can over the engine
and takes out a dense root harvested from her husband's
maguey patch. She drills into it with a Phillips Head,
releasing the sweet fluid into Jose's sacred abalone—
still stained from years of copal and coal. With this
she mixes a smidgen of bathtub whiskey smuggled in
from Rough & Ready and the strong 7-Eleven infusion.
As it cools, she holds a pastilla in her palms and
commands Jose to take it, to hold it, to suck.

The vapors form blue eddies that sing in the Comandan-
te's ears. They press the sticky pads of their
translucent fingers into his temples until he falls
into a half sleep. Juana breathes onto the Phillips
Head and wipes it clean with her reboso. She steadies
it over his bare chest and twirls the handle between
her palms until there is smoke. Until there is heat
enough to penetrate his flesh. She plunges it into
the yolotl until its beating vibrates up her arms.
She grabs the silkscreen squeegee, turns it on its
side, digs one end into the chest cavity. She slices
downward, toward the naval. A mist rises. It smells
of coal. With both hands, she pries him
open, peels the outermost layer of his skin.
She drapes over her She inserts him. She
inserts her hands into his corazon, probes the hot,
clotting blood and removes the body of a bird. A
hummingbird. A yollotototl with a band around its
ankle. A tracking device. She burns through the
plastic with a lighter releasing its leg. She
places the tag in the abalone shell with a fresh
pinch of copal and watches its shape change. She
wipes the bird, who struggles for breath, and dreams
it alive again in an unnamed tongue. Juana lodges
a crystal shard in its beak, for which she charges
the winged creature stewardship. She lowers the
yollotototl back into the warm chamber, threads the

Fig. 49. RCAF Flight Log: Fowler—
Las Vegas, 1970. 6" × 9.5".

Fig. 50. RCAF Evidence Bag: tea,
2010. Photo by Jesse Vasquez.

Fig. 51. RCAF Evidence Bag:
screwdriver, 2010. Photo by
Jesse Vasquez.

squeegee, turning it on its side, dipping one end into the chest cavity. She slices downward, toward the navel. A mist rises. It smells of ocean. With both hands she pries him open. She unpeels the outermost layer of his flesh. She drapes it over her own. She inhabits him. She inserts her fingers into the yolotl, probes the hot, clotting blood and removes the body of a bird. A hummingbird. A yollotototl with a band around its ankle.

Juana recognizes the band as a tracking device. She burns through the plastic with a lighter, releasing its leg. She places the tag in the abalone shell with a fresh pinch of copal and watches its shape change. She wipes the hummingbird, who struggles for breath, and dreams it alive again in an unnamed tongue. She lodges a shard of crystal in its beak, for which she charges the winged creature stewardship. She lowers the yollotototl back into the warm chamber, threads the dry tip of the maguey with its own fibers and stitches the skins together. A ridge forms and heals under her touch with the help of a nearby can of WD-40.

José awakens at dawn. Sound comes.

Depart: Bakersfield; Destination: Delano (red-eye flight)
Make: Califia
Model: 1850
Pilots: Major Disaster and General Confusion

Louie and Rudy, having set up a serigraph press in the back of the plane, are silkscreening by the light of Chicomecoatl. At the moment Quetzal-coatl is ascending from the fifth underworld, they deliver the posters to Cesar. Pilots [are] charged with the guarding of Cesar as the ground troops march toward Sacras: Sign of the four directions if you see adobe airplanes above. Look up or across city streets lined in murals, silk-screens. In communities built around centros y lucha. They wrap you in laughter, in la locura que cura. El grán comandante in his feathered helmet and scaled robe opens his fighter jacket and songs are released. Conchas sound. Notice his wings, the engravings in gold that decorate his shoulders.

One by one the pilots parachute down, with Villa in the lead. The ala-baster on the façade of the California State Capitol cracks, bleeds into the valley of oaks and up the leg of the pedestal that displays the head of Joaquín Murrieta, into the museum that houses the blue fermented body of Ishi, the Last California Indian. Pancho Villa's head rolls off the Teatro Campesino stage. Lola Montez steps out on her Grass Valley porch in a negligee with her black hair braided and 174 Cornish miners on a leash. General Villa sketches a portrait of her in blue and fuchsia Prismacolor Four-In-One markers.

At the dawn of the Fifth Sun, they converge on the Capitol steps for a demonstration of roses. Cesar Chavez gives the opening remarks. The crowd raises huelga flags. Montoya recites a poem he has written in Caló. It has been rejected seventeen times by the yanquí presses in Nueva York, but Chusma House is being formed as he speaks. But the crowd does not need the stamp of publication when they hear his canto, its coos and fury. Some cheer, some cry out as if to mariachi.

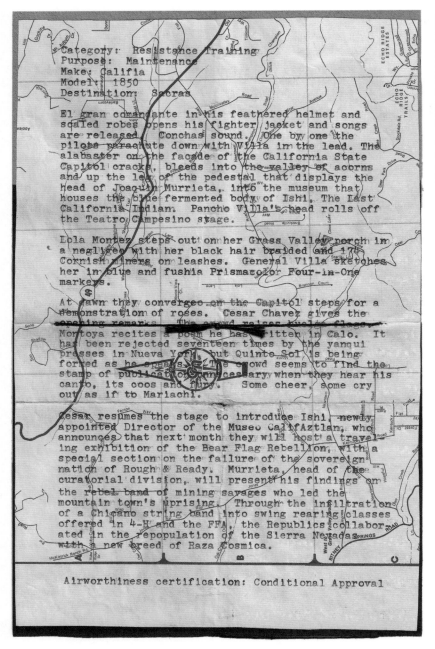

Category: Resistance Training
Purpose: Maintenance
Make: Califia
Model: 1850
Destination: Sacras

El gran comandante in his feathered helmet and
scaled robes opens his fighter jacket and songs
are released. Conchas sound. One by one the
pilots parachute down with Villa in the lead. The
alabaster on the façade of the California State
Capitol cracks, bleeds into the valley of acorns
and up the leg of the pedestal that displays the
head of Joaquín Murrieta, into the museum that
houses the blue fermented body of Ishi, The Last
California Indian. Pancho Villa's head rolls off
the Teatro Campesino stage.

Lola Montez steps out on her Grass Valley porch in
a negligee with her black hair braided and 17
Cornish miners on leashes. General Villa sketches
her in blue and fushia Prismacolor Four-in-One
markers.

At dawn they converge on the Capitol steps for a
demonstration of roses. Cesar Chavez gives the
opening remarks. The crowd raises their glasses.
Montoya recites a poem he has written in Calo. It
has been rejected seventeen times by the yanqui
presses in Nueva York, but Quinto Sol is being
formed as he speaks. The crowd seems to find the
stamp of publication unnecessary when they hear his
canto, its coos and fury. Some cheer, some cry
out as if to Mariachi.

Cesar resumes the stage to introduce Ishi, newly
appointed Director of the Museo CalifAztlan, who
announces that next month they will host a travel-
ing exhibition of the Bear Flag Rebellion, with a
special section on the failure of the sovereign
nation of Rough & Ready. Murrieta, head of the
curatorial division, will present his findings on
the rebel band of mining savages who led the
mountain town's uprising. Through the infiltration
of a Chicano string band into swing rearing classes
offered in 4-H and the FFA, the Republics collabor-
ated in the repopulation of the Sierra Nevada
with a new breed of Raza Cosmica.

Airworthiness certification: Conditional Approval

Fig. 52. RCAF Flight Log:
Delano—Sacras, 1969. 6" × 9.5".

Fig. 53. RCAF Evidence Bag: acorns,
2010. Photo by Jesse Vasquez.

Cesar resumes the stage to introduce Ishi, Executive Director of the Museo CalifAztlán, who gives an eloquent account of the 1849 Gold Rush. He points to their newest exhibition of the eating habits of miners, and a crowd gathers in wonder at how they could stomach the pasties stuffed with turnips or the crude whiskey made in lime-scaled tubs while nearby Nisenan feasted on acorn cakes and roasted venison. The audience cheers when he lights up the model of a saloon and the cornhusk figurines do their finest rendition of an Irish jig.

Next month, he announces, they will host a traveling exhibition of the Bear Flag Rebellion with a special section on the failure of the sovereign nation of Rough and Ready. Murrieta, head of the curatorial division of CalifAztlán, will present his findings of the rebel band of miners who led the mountain town's uprising. With the infiltration of a Chicano string band into swine-rearing classes offered in 4-H, the Republics corroborated in the repopulation of the foothills of the Sierra Nevadas by a new kind of Raza Cósmica.

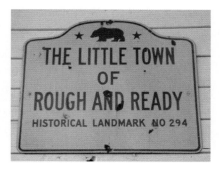

Fig. 54. Rough and Ready sign, 2014. Photo by La Stef.

FLIGHT LOG II *

Sacras–San Diego

Depart: Sacras; Destination: San Diego
Comandante José Guadalupe Posada
Compilots Josie Talamantez, John Rollin Ridge, and Armando Cid

Pilots refill their tanks at El Centro Cultural de La Raza, the storefront of which disguises the unsanctioned use of two water supply towers now holding maize fuel for Royal Chicano Air Force and naval operations.

Fueling up, Josie Talamantez overhears two visitors talking about a set of original printing blocks from Mexico's renowned printmaker José Guadalupe Posada. She shares the information with her copilot, Armando Cid, and the two approach Centro staff in search of clues. An intern points them to a man in dusty blue jeans inspecting the community bulletin board. La Josie initiates conversation about an upcoming tardeada and the man perks up, but offers limited information about his plans for the evening. After an hour of engaging exchange and the revelation that La Josie once served as director of the Centro, they gain the man's confidence. He reveals his real name—asking that it not go on record at this time—and his relation to the late J. G. Posada. According to the man's story, he is the great grandson of the iconic illustrator's longtime employer, Antonio Vanegas Arroyo, and has just successfully smuggled Posada's original printing blocks from Chilangoxtitlán across the US-Mexico border with the help of a coyote who only charged tres mil pesos for the whole endeavor, unaware as he was of the true value of his cargo. The grandson explains that he had taken on the tremendous risk after watching the Mexican government fail to preserve and elevate the work of this national treasure. He explained that he had watched as foreign art dealers from Chicago and Europe traveled south to collect the famous satirical broadsides and amass collections larger than any in Mexico. He had also heard of Posada's influence on artists involved with the Chicano renaissance up north and decided to take it upon himself to deliver the priceless artifacts to those who would truly appreciate them. Elated, Cid and Talamantez tell him of making posters for the farmworker's movement and the group's idolization of Posada. The great grandson stares at them a moment and, finally, agrees to show them the original blocks.

* This Flight Log was recovered on La Stef and Miss Ella's expedition to retrieve the stolen Royal Chicano Air Force archives [see Recovering the Stolen Archives]. It was later determined to be a reproduction of the original, which has yet to be located. This particular log has since been revealed to be a fraud, as indicated by the solid red and black ink as opposed to the original, which contained the Roman script in mixed ink colors. However, extensive research on the part of Miss Ella has led us to believe that they do not contain an accurate duplication of the original content.

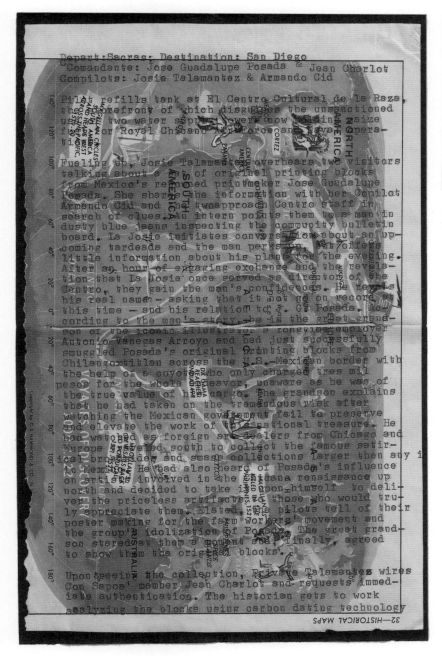

Depart: Sacras. Destination: San Diego
Comandante: Jose Guadalupe Posada & Jean Charlot
Compilots: Josie Talamantez & Armando Cid

Pilot refills tank at El Centro Cultural de la Raza, the forefront of which disguises the unsanctioned use of two water supply towers now holding maize for Royal Chicano Air Force and Navy Operation.

Fueling up, Josie Talamantez overhears two visitors talking about a set of original printing blocks from Mexico's renowned printmaker Jose Guadalupe Posada. She shares the information with her Copilot Armando Cid and the two approach Centro staff in search of clues. An intern points them to a man in dusty blue jeans inspecting the community bulletin board. La Josie initiates conversation about an upcoming tardeada and the man perks up, but offers little information about his plans for the evening. After an hour of engaging exchange and the revelation that La Josie once served as director of the Centro, they gain the man's confidence. He reveals his real name — asking that it not go on record at this time — and his relation to J. G. Posada. According to the man's story, he is the great-grandson of the iconic illustrator's longtime employer Antonio Vanegas Arroyo and had just successfully smuggled Posada's original printing blocks from Chilangoxtitlan across the U.S.-Mexican border with the help of a coyote who only charged tres mil pesos for the whole cleaver, unaware as he was of the true value of his cargo. The grandson explains that he had taken on the tremendous risk after watching the Mexican government fail to preserve and elevate the work of the national treasure. He had watched as foreign art dealers from Chicago and Europe traveled south to collect the famous satirical broadsides and swamp collections larger then any in Mexico. He had also heard of Posada's influence on artists involved in the Chicano renaissance up north and decided to take it upon himself to deliver the priceless artifacts to those who would truly appreciate them. Elated, the pilots tell of their poster making for the farm workers' movement and the group's idolization of Posada. The great grandson stared at them a moment and, finally, agreed to show them the original blocks.

Upon seeing the collection, Private Talamantez wires Con Safos' member Jean Charlot and requests immediate authentication. The historian gets to work analyzing the blocks using carbon dating technology

Fig. 55. RCAF Flight Log: Sacras—
San Diego, 1975. 6" × 9.5".

Fig. 56. RCAF Evidence Bag: peso, 2010.
Photo by Jesse Vasquez.

Upon seeing the collection, Private Talamantez wires Con Sapos' member Jean Charlot and requests immediate authentication. The historian gets to work analyzing the blocks using carbon dating technology and agave fiber graphing, as well as an in-depth study of area chisme. Once confirmed, the great grandson grants special permission to Cid and Talamantez to hold a clandestine printing operation on Michael Algo's press. Armando, being a master printmaker in addition to an RCAF pilot, handles the engraved surfaces and pulls the prints himself.** La Catrina orchestrates the efficient use of drying racks as the great grandson himself prepares the inks.

** In records found in the Oral Vaults, La Josie describes the cleverly orchestrated printing session as a magical experience, one that may or may not have led to her subsequent marriage to the dedicated printmaker. What for sure resulted from their all-night efforts was the creation of a suite of prints that was exhibited throughout Aztlán, including Los Angeles, San Francisco, Milwaukee, and Sacramento. The La Raza Bookstore and Galería Posada archives at California State University, Sacramento, show that, in total, sixty-six broadsheets illustrated by Posada along with two of the original zinc plates were exhibited at "La Bookstore" in Sacramento from June 13 to July 12, 1980. In honor of the exhibit, Terezita Romo named the nascent gallery space "La Galería Posada." Years later, La Josie found the remaining prints on sale at La Raza Bookstore and Galería Posada in Sacramento for one dollar each.

Depart: Las Vegas; Destination: CA-NV State Line
Make/Model: Entire Fleet
Pilots: All

Pilots aim their crafts in the direction of three designated middle and high schools in the Las Vegas vicinity, on their way to give inspirational presentations about the Royal Chicano Air Force to students in the professional training program. The pilots, dressed in full regalia, are well received by the first classes. They field thoughtful questions and demonstrate daring maneuvers. At the second and third schools, the receptions are chilly and students remain unaffected. Even the Force's most heartfelt testimonios are of no use. The pilots stop for lunch on the outskirts of the city near a cropping of power lines heading toward downtown. They relax and discuss their failures when the assistant charged with guiding them mentions that the children's parents are either growers or farmworkers who work for the growers and that, around here, the growers do not look kindly upon the Air Force's relations with Cesar Chavez and his union.

Lunch ends and the pilots load up for takeoff. Arriving more than twenty minutes late according to the administrator's watch, the crew spots a huge crowd. The entire school has gathered to greet them with overwhelming applause. Wheels go down and each plane lines up to the landing strip. Finally, they arrive at the main doors in theatrical unison, piling out. They notice an entire squadron of police cars circling them, sirens blaring. The officers jump out, pumping their rifles, barrels pointed directly at the pilots. The young officers' fingers hover above their triggers, trembling. "We know who you are," screams the chief of police. "Who do you think we are?" barks Major General Montoya. "You're the Symbionese Liberation Army and you've come to blow up the power lines into Las Vegas!" Holding back his rage in an impressive display of restraint, the fired-up Major General explains that they are in fact not the infamous kidnappers of Patty Hearst, but a royal air force performing their civic duty by encouraging the bright young leaders of tomorrow. Receiving confirmation over his radio, the police chief commands his officers to

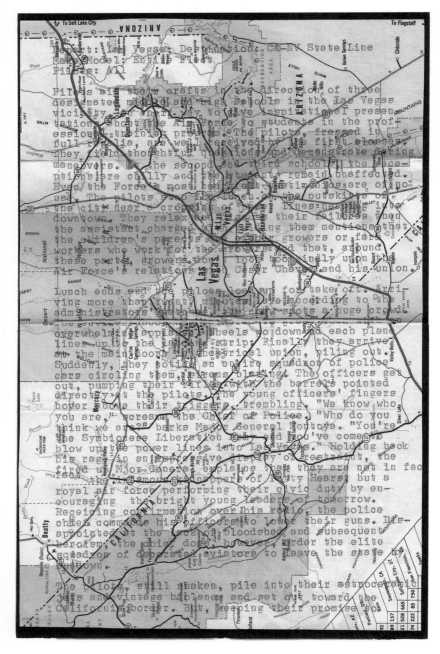

Fig. 58. RCAF Evidence Bag: machine,
2010. Photo by Jesse Vasquez.

Fig. 57. RCAF Flight Log: CA—NV
State Line, 1976. 6" × 9.5".

lower their guns. Disappointed at the lack of bloodshed and subsequent heroism, the chief does, however, order the elite squadron of decorated aviators to leave the state by sundown.

The pilots, still shaken, pile into their astroceramic jets and vintage adobe biplanes and set out toward the California border. But, keeping their promise to attend a special dinner in their honor, the fleet veers north and does not make their deadline. Instead, they end up at their host's residence on the outskirts of a sprawling ranch to enjoy an abundance of barbecued ribs.

At the end of their meal, one of the pilots notices a herd of horses in the corral next door and asks their host if they might take a ride since, in addition to being accomplished aeronautical engineers, they are also experienced equestrians. The host graciously offers the services of his neighbor's steeds, and the pilots enjoy an invigorating ride. Once finished, they cool down their mounts and lead them back to the stalls, taking notice of the imposing structure and the fact that each horse has its own sauna. They press the host for the owner's name. "Oh, these are Wayne Newton's prized Arabians. But he's away on business in Sicily."

Without a moment's hesitation, the pilots thank their host for his generosity and make their way skyward, aircrafts pointed west.

FLIGHT LOG

Sacramento Concilio–
Alkali Flats

WORKING IN collaboration with Oak Park's Black Panthers, who had utilized the RCAF fleets for their own community organizing efforts on occasion, the pilots load up their adobe vessels with huevos, chorizo, tortillas, milk, and orange juice. The chefs have adapted the rear engine cavities into working kitchens in order to prepare the ingredients—both donated and city-funded—into piping-hot meals. The carefully wrapped nutrients are then parachuted down with one trained jumper at a time and fed to a hungry child before the school day begins.*

On this mission at an hour so early that only those deeply committed or hailing from a farmworker background could uphold it, Private Talamantez held the checklist to her chest as she tallied the ingredients and marked them off one by one. Today, their supply was short by fifteen bushels of the corn masa used to make the fresh tortillas. Sergeant Rosemary Rasúl loaded up the pallets until her brother David arrived, then went on to prepare the kitchen area, restocking the pico de gallo, napkins, and utensils. Several minutes later all the pilots were accounted for and in uniform, their aircrafts loaded. Squadron leader Terezita Romo suited up and took the helm of Sergeant Rasúl's craft, a newly restored Metate X-5000.

When Talamantez completes the final inspection, the two are cleared for takeoff. The sergeant gets to work once they hit two hundred feet. She had mentioned the maize shortage to Romo as they ascended, but had not assumed the pilot would risk missing their delivery deadline to do anything about it, much less invade one of the nearby factory farms in Dixon and proceed to negotiate with the owner—a staunch United Farm Workers Union adversary—for payment of the children's due share of back pay in fresh corn. Unfortunately, there were no witnesses to Romo's successful negotiation, so no statements can be made to testify to the pilot's sheer cunning and ingenious use of the nascent farm labor laws. Fortunately, though, the fifty bushels of maize were of an heirloom variety that still retained many of the vital nutrients necessary for the young children's growing bodies and absorbent minds.

As sergeant and lead chef, Rasúl turned the fresh fibers into warm tortillas, soaking the kernels in a bath of lime and a pinch of ash at just the right time as her ancestors had been shown and had thus shown her.**

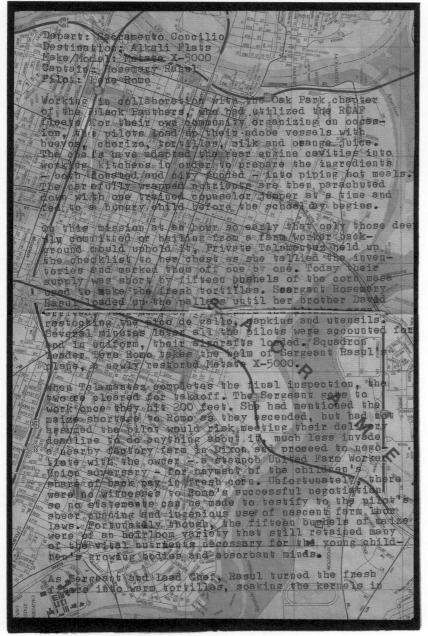

Depart: Sacramento Concilio
Destination: Alkali Flats
Make/Model: Metate X-5000
Captain: Rosemary Rasul
Pilot: Tere Romo

Working in collaboration with the Oak Park chapter of the Black Panthers, who had utilized the RCAF fleets for their own community organizing on occasion, the pilots load up their adobe vessels with huevos, chorizo, tortillas, milk and orange juice. The chefs have adapted the rear engine cavities into working kitchens in order to prepare the ingredients – both donated and city funded – into piping hot meals. The carefully wrapped nutrients are then parachuted down with one trained counselor jumper at a time and fed to a hungry child before the school day begins.

On this mission at an hour so early that only those deeply committed or hailing from a farm worker background could uphold it, Private Talamantez held up the checklist to her chest as she tallied the inventories and marked them off one by one. Today their supply was short by fifteen bushels of the corn masa used to make the fresh tortillas. Seargant Rosemary Rasul loaded up the pallets until her brother David arrived, restocking the pico de gallo, napkins and utensils. Several minutes later all the pilots were accounted for and in uniform, their aircrafts loaded. Squadron leader Tere Romo takes the helm of Sergeant Rasul's plane, a newly restored Metate X-5000.

When Talamantez completes the final inspection, the two are cleared for takeoff. The Sergeant gets to work once they hit 200 feet. She had mentioned the maize shortage to Romo as they ascended, but had not assumed the pilot would risk meeting their delivery deadline to do anything about it, much less invade a nearby factory farm in Dixon and proceed to negotiate with the owner – a staunch United Farm Worker Union adversary – for payment of the children's share of back pay in fresh corn. Unfortunately, there were no witnesses to Romo's successful negotiation, so no statements can be made to testify to the pilot's sheer cunning and ingenious use of nascent farm labor laws. Fortunately though, the fifteen bushels of maize were of an heirloom variety that still retained many of the vital nutrients necessary for the young children's growing bodies and absorbant minds.

As Sergeant and lead Chef, Rasul turned the fresh fritters into warm tortillas, soaking the kernels in

Fig. 59. RCAF Flight Log: Sacramento
Concilio—Alkali Flats, 1971. 6" × 9.5".

Fig. 60. RCAF Evidence Bag: tortilla,
2010. Photo by Jesse Vasquez.

THE LOST CODEX

Although there are very few
surviving pre-conquest codices,
the tlacuilo (codex painter)
 tradition endured the transition
to colonial culture; scholars now
have access to a body of around
 500 colonial-era codices.

Fig. 61. La Stef, Index Note #11:
Codices, 2008. 3" x 5".

THIS TELLING codex was recovered beneath a pile of loose-leaf transcripts from documentary filmmaker Steve LaRosa's archives. Decoding has been aided by firsthand accounts found in the Oral Vaults and a pirated version of LaRosa's Royal Chicano Air Force documentary, *Pilots of Aztlán*. [Note: Since its recovery, this codex has been lost to a destructive Circle C virus, a prevalent plague among published archival matter. Its modern transcription, however, is still available to us here.]

1. Troops leave their base in SacrAztlán.

2. They travel under the influence across the Central Valley toward San Juan Bautista.

3. There, Luis Valdéz has organized a meeting at the Teatro Campesino headquarters to organize a formal coalition of cultural centros throughout California.

4. Maestro Andrés Segura was giving a profound palabra over the sacred fire on what it meant to be indígena, an indigenous person on this continent. The fleet of RCAF planes landed in irregular formation.

5. With a full bladder, Rudy Cuellar walked over to the sacred fire, "whipped out his dick" (literal translation) and "pissed until he put the sacred fire out."

6. Maestro Segura was infuriated and rallied the others to chase the pilots out.*

* Under further investigation, it has been revealed that this codex panel was intentionally manipulated to send a moral message that would ensure respect toward the danzante traditions rather than preserve the truth, which was that the pilots stayed, joined the circle, and went on to participate in the creation of the Concilio de Arte Popular.

C/S,* THEREFORE IT IS:

Fig. 62. Holy Water, 2008. Photo by La Stef. From the
collection of the Con Sapos Preservationists Society.

* Depending upon whom you ask,
 I am an unreliable narrator.

AN INTERLUDE

INFAMOUS
ACCIDENTS

> For years, members of the RCAF
> did not sign their work except
> with the letters of the group.
> No dates either.
>
> Archivists hate this.

Fig. 63. La Stef, Index Note #12:
Archivists Hate This, 2008. 3" × 5".

Fig. 64. La Stef, Index Note #13: Holy Angels, 2004. 3" × 5".

Depart: Woodland; Destination: Tulare
 (AKA: La NASA Sapotécnica Incident)

Date:
 1 Jaguar, Cycle 17, Fourth Sun

Subject:
 Materials Research for Space Capsule Construction

Report:
 General E. Pound enters Royal Chicano Air Force (RCAF)
 Headquarters located at the Reno Club in Alkali Flats
 of SacrAztlam. He encounters Esteban Villa, Comandante
 of the RCAF and Subcomandante of the Royal Chicano Naval
 Forces in Fresno, who is cleverly disguised as an artist.
 Gen. Pound orders two drinks, knowing the Comandante will
 not refuse. Villa opens up his 4"x6" drawing pad, pulls
 out his Five-In-One Prismacolor markers and begins to
 sketch Gen. Pounds portrait. Gen. Pound concludes that
 the Comandante has again forgotten their scheduled meet-
 ing. Gen. Pound lays out NASA"s offer of limitted air rights
 to the Sacramento Basin, Sierra Nevada Foothills and San Fran-
 cisco Bay Area (including Berkeley), as well as unlimited
 landing strip use on the constellations of Venus and Gem-
 initli in exchange for information leading to the develop-
 ment of NASA space travel capacity.

 Comandante Villa hesitates, but finally negotiates to
 share the RCAF intelligence upon being granted additional
 requests of fresh menudo served weekly at the Headquarters
 and private modeling sessions with the General's daughter
 nightly.

 Gen. Pound agrees without reservation except to clarify
 as to whether the RCAF requires FDA Organic Certification
 of the tripe. They both lift their glasses to salute
 ceramic space technology.

 Comandante Villa leans in, lowering his voice:
 "It"s a New Mexican Recipe"

Fig. 66. La NASA Sapotécnica Incident (notes),
1986. 8.5" × 11".

LA NASA SAPOTÉCNICA INCIDENT

Fig. 65. Esteban Villa. Untitled
(sketch). © Esteban Villa. Courtesy
of Esteban Villa. 4" × 6".

The Archivist Dreams

SCENE I

I am seated for dinner around a long table with the troops. There has been an FBI hit called on Comandante Montoya and the RCAF. There are spies in the fake foliage of the restaurant. Montoya is at the head of the table, giving direction. Everyone is in grayscale. I am wearing green.

The troops discuss maneuvers, what this hit order means, who called it. I record the proceedings. I am to archive. To guard the red and black ink. It is agreed. A consensus at the great table. They move on to new business.

SCENE II

Juanita and I are at the bar. We befriend the bartender—a beautiful young woman—who is an agent out to kill us. We befriend her to the point that she changes her allegiance. We sense two other snipers in the plants behind us and in the crowd. We escape.

THE TAKEOVER
OF THE TANK

"You're going to confuse archeologists
500 years from now."

-Sam Rios, PhD

SCENE III

The troops and I are being held hostage in the lobby of an upscale hotel, in a rec room off to the side. We are playing. The atmosphere is light, intense. I spot a man with a hat standing next to a potted tree. He withdraws a grenade. I jump over a partition and duck. The man with the hat throws the grenade, causing an explosion that leaves nothing but bloodstains. I survive.

I see the man walk away, down a hall. Hotel staffers are already scrubbing the walls, suds dripping down the surface. They do not notice I am alive. I run down the hall for help and find a bellhop leading people to their rooms. He does not notice me. He does not acknowledge the bloody walls. I know his connections.

I run back into the room. All walls that surround me are covered in crusted red outlines of those I know. The workers continue to scrub.

I continue to look. Overwhelmed, unable to cry. I receive a telepathic message that the pilots are alive. That the troops in the rec room were stand-ins. Comandante Montoya had foreseen all this.

There is a story I have not yet
retrieved from the oral vaults of
the elders, referred to as "The
Takeover of the Tank."

Please, if you hear it, fill me in.

THE FOLLOWING document was found among the City of Davis' Public Archives and pertains to the controversial hearing of the Royal Chicano Air Force vs. Yolo County. It has since been returned to the Con Sapos Archaeological Society Archives.

THE YOLO COUNTY CROP DUSTER INCIDENT

In 1971, the RCAF was indicted in a Davis tribunal for the destruction of a crop duster in Yolo County, California. A report published in the Sacramento Bee claimed that an unmarked plane in "Cesar Chavez's Air Force" had forced down the privately owned duster carrying twenty-three kilos of DDT.

The RCAF was represented in court by Frank "The Fox" Godina, while Mayor Joe Serna, Jr. worked diligently to raise funds for their bail. No member of the RCAF was ever found or jailed.

Fig. 69. La Stef, The Yolo County Crop Duster Incident (notes), 2009. 8.5" × 11".

The excess funds went into the purchase of serigraph supplies for posters denouncing Safeway and Gallo Wines. A scrupulous review of financial records found that the funds were in actuality diverted to a blacked-out purchase from San Francisco's Mission District. Supplies and fresh limes were bartered for, but written off as purchases for tax purposes.

The Archivist Dreams Again

I stop by the Galería Posada to see their most recent exhibit. People I do not know are hanging José's pieces—special limited-edition works on thin sheets of metal. People are making a fuss about the paints used—a rare, recently outlawed toxic mixture that produces brilliant color atop the dull surface. Someone confuses my admiration, thinking I am a collector, and purchases one in my name.

I have plans to travel and find the new acquisition a hindrance, an extra piece of luggage I cannot afford to carry with me. I sit on the gallery floor. Piece by piece, I consume the painting. I take it into my mouth, chew it, let it slide down my throat into my stomach.

Afterward, I consider the money I could have gained by selling the piece, the money I will never recover. But now I am free to move, the painting inside me.

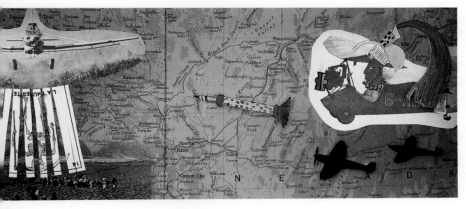

Fig. 70. The Yolo County Crop Duster Incident (hieroglyph), 2014. 7.5" × 14". Photo by Jesse Vasquez.

A USDA OFFER

OFFICIAL REPORT extrapolated from the United States Pentagon. It now resides in the Con Sapos Historical Society Archives.

A USDA Offer

In the late 1970s, the United States Department of Agriculture approached Comandante₁Montoya for the Royal Chicano Air Force's recipe for maize fuel. Knowing the implication's the divulgence of the secret recipe would have on wild, indigenous grains still grown throughout the Americas, the comandante refused to release the information even despite the fact that the officials were prepared to pay top dollar in their attempt to alleviate the national economy from its dependence on foreign oil.[2]

Over time, however, those officials were able to develop a version of the secret jet fuel compatable with automobiles thanks in part to Tatiana Proskouriakoff, the famed archeologist credited with finally cracking the code of the ancient Mayan glyphs. Inside the glyphs had remained partially transcribed a variation on the ancient recipe. Though the Maya were not known to drive automobiles through the dense jungles they inhabited, scientists on government payroll were able to adapt the key ingredients for ground transportation purposes.[3]

Fig. 71. La Stef, A USDA Offer (notes), 2008. 8.5" × 11".

1. The key being excess levels of niacin produced when processed with fresh lime juice.

2. Though tempted at times of severe fiscal need and pressured by threats from the Federal Bureau of Investigation, the RCAF never gave over the recipe for their sacred concoction. Indeed, it is rumored that even the pilots themselves are only privy to portions of the ingredients and sworn to secrecy on their lives. René Yáñez is the only one said to carry the recipe in its entirety.

3. This national project was made possible by lobbying efforts to the United States Department of Agriculture by the Southern California Regional Transit Authority and the American Automobile Manufacturers Association.

OMISSION
REGARDING

AN
OMISSION
REGARDING
LOUIE "THE FOOT"
GONZALÉZ

RECOVERING THE STOLEN ARCHIVES

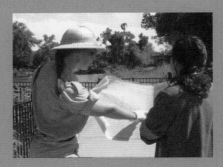

Fig. 72. La Stef and Miss Ella
Recovering the Stolen Archives,
2010. Photo by Samuel Quiñones.

RECENTLY, the Con Sapos team organized an expedition to the heart of Castilla y León to recover not the famed precious metals extracted from the Americas, but the archives of the Royal Chicano Air Force that have been relocated—either legally or by illegal means—to various museums and cultural centers that, according to the brochures, "illustrate the splendors of Imperial Spain."

Leading the expedition was La Stef and cartographer Miss Ella. Aside from a minor setback at the Madrid-Barajas International Airport in which Miss Ella was detained and denied entry into the Iberian Peninsula until The Fox came to her legal rescue, their plans went along rather smoothly.

In all, the two recovered vital RCAF archives from the Catedral and Plaza Mayor in Salamanca, along with the Casa de América, Plaza Mayor, and Museo Arqueológico Nacional in Madrid. Examples can be found on the following pages and throughout the exhibition.

FOUND IN La Casa de América in Madrid, Spain, this postcard dates from the Third Sun. The museum inscription below reads as follows: *Fascsímile del pasaje en la Cosmographia Introduction (1507) en la cual por primera vez se sugiere el nombre «América» para el Nuevo Mundo.* Originally composed in Latin, the postcard, addressed to royal officials in the capital of Castile, evidences the first encounter of European explorers with generals of the Royal Chicano Air Force on an adobe airplane ride at a popular Aztláneco amusement park.

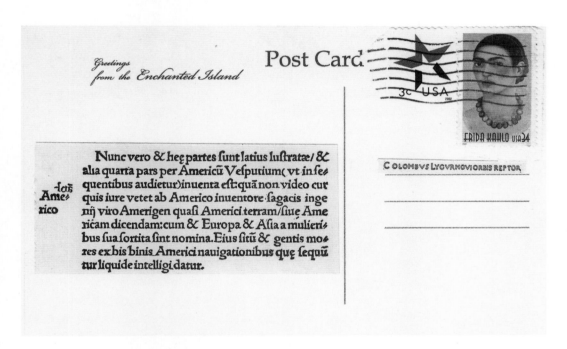

Fig. 73. First RCAF Postcard, 2008.
4" × 6".

A CLOSE CALL AS CESAR'S SECURITY

THIS MAP, which was originally used in the cockpit of RCAF Commander José Montoya's C-29 adobe aircraft, is unique to the fleet of the Royal Chicano Air Force in that it was later utilized as a scroll to document one of the Force's near-lethal encounters while serving as security for Cesar Chavez at a United Farm Workers Union rally in Davis, California. The map itself blends the standard French aeronautical map-and-holder model with that developed by the Eagle Knight Warriors serving under Moctezuma II, allowing pilots to steer the aircraft with one hand while turning the scroll map with the other. It is the same model used in World War I, El Movimiento Chicano, and the Maguey Wars of 2012.

With the help of a handful of code-switching scholars and a series of meticulously transcribed oral history accounts, the Con Sapos archaeological team has deciphered the pictographic language in which an unnamed scribe recorded the day's events. We have carefully translated its contents on the following page, and included archival annotations when necessary:

United Farm Worker Union leader Cesar Chavez had made his way to Davis, California, to address a crowd of sympathetic listeners. Members of the Royal Chicano Air Force (identified by their green uniforms with the exception of General "Confusion" Esteban Villa, who came attired in his usual lunar exploration suit) were providing security for the union organizer, whom they affectionately referred to as "The Little Guy." Chavez's personal secretary Richard Ybarra secured the stage. During a rousing speech on walkouts in Yolo County, the union leader became so impassioned by his commitment to La Causa, or the plight toward social justice for all farmworkers, that the bodyguards noted a visible shift in the crowd that now rallied behind him after having been so moved.

At that moment RCAF pilot Ricardo Favela, positioned imperceptibly in the crowd for Chavez's protection, noticed two snipers poised atop an apartment complex just across the street from the park with a missile aimed straight for the union leader's chest. The pilot motioned another Air Force member on Chavez's right, who made the leader aware.

Facing. Fig. 74. Cesar's Security (hieroglyph), 2011.

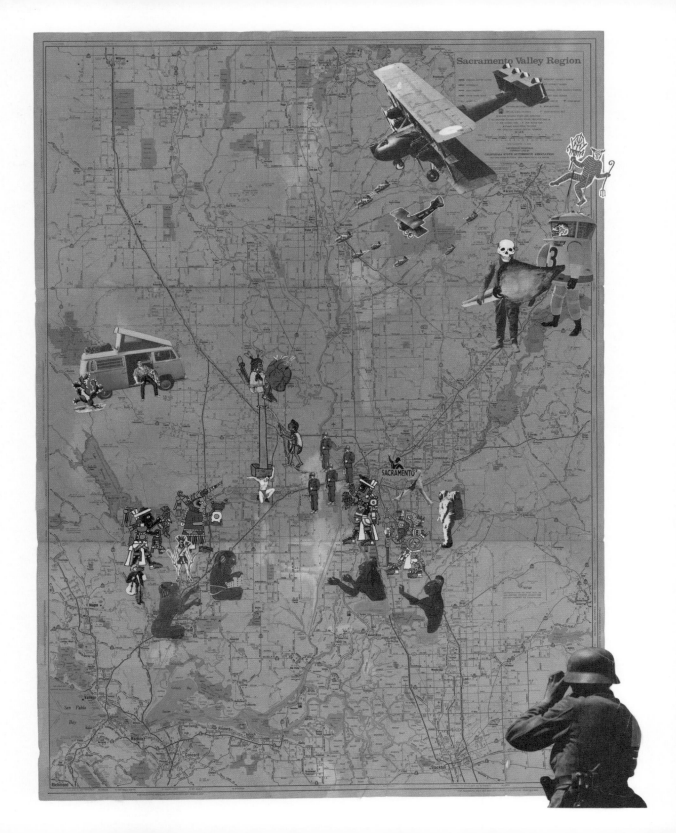

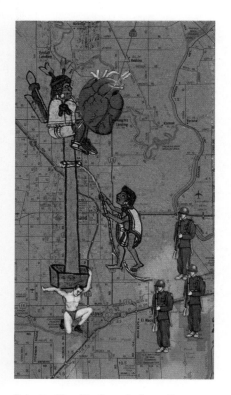

Detail. Fig. 74. Cesar's Security
(hieroglyph), 2011.

"The Little Guy" immediately "went limp," says fellow pilot Juanishi Orosco, then turned himself inside out so that all that was visible of his once petite but formidable self was his heart, exposed and beating for all to see. As another witness described the change, "it was as if he were just tempting the assassins to make a martyr of him in front of all those folks." According to scholars, Chavez, following in the Aztec and Mayan traditions of human sacrifice, had updated the practice and used, instead of another human, himself as sacrificial victim. In the few split seconds—though it is recorded that all temporal measurement devices actually paused—the vulnerable heart tissue was swaddled in gauze and taken under the protection of two federal agents charged with avoiding the union leader's martyrdom. They cleared a corridor in the crowd as pilots Louie "The Foot" and Ramón Ontiveros hurried the organ into Chavez's beat-up Dodge Dart, summoning the RCAF squadron to follow, for they were legend to be useful in the reconversion process.

A MAJOR FIND!

RCAF Time Warp in the
Tunnel Mural

LED BY the tireless and meticulous efforts of Miss Ella, the Con Sapos team has been at work over the last ten years on an excavation site that spans Sacramento's newly developed West End from Eighth Street to the riverfront and from D and V Streets on the city's Roman grid. Six years in, our star cartographer unearthed a semi-functioning computerized control panel. After applying copal resin to stabilize corrosion and after several years of rewiring and trial connections, Miss Ella made the exciting discovery that the K Street Underpass, replete with its controversial RCAF murals, has also been used as an under-the-radar "time warp."[1] She found that before one passes through the tunnel, known locally as L.A.S.E.R.I.U.M., one could program a specified temporal locale into the control panel, giving the mural's light elements permission to reconfigure one's body and transplant it temporarily into an intersecting time frame.

Fig. 75. Miss Ella, 2010.
Photo by Samuel Quiñones.

Fig. 76.
La Stef, Con Sapos
Excavation Log,
2010. Photo by
Jesse Vasquez.

gum wrapper and a worn penny. The volunteer crew grew weary; we broke early.

7-DEER. TUESDAY. Another day without any discovery. But we moved earth, kept digging. I love "The Foot" came by the site and read us his latest poem, some news articles.

1-FROG. WEDNESDAY. A volunteer unearthed two preserved seeds. At 2:37pm, another retrieved a fragment of what looks to be gourd. The concave shape measured 0.6", indicating that it was not a mature sized gourd or may have been something altogether distinct. A preliminary assessment by the team resolved it to be part of a rattle of some sort, perhaps one employed during the ancient ceremonies.

3-CARROT. THURSDAY. Unearthed one strip — 1.3" x 4.2" — faux jaguar pelt. A smattering of blood. Had it shipped to Con Sapos headquarters for DNA testing. Also found one unidentified phone; also sent to headquarters.

16-SQUIRREL. FRIDAY. Volunteer crew of three uncovered seven planks, partially assembled still from

1. Miss Ella's own words, as recorded here: "Flying under the Radar with the Royal Chicano Air Force: The Ongoing Politics of Space and Ethnic Identity." PhD diss., College of William and Mary, 2010.

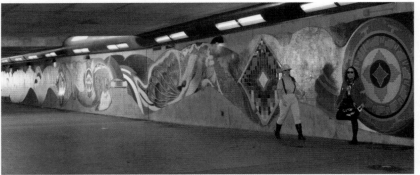

Fig. 77. La Stef and Miss Ella at the L.A.S.E.R.I.U.M. Excavation Site, 2012. Photo by Jon Alston.

Fig. 78. Stephanie Sauer, RCAF Evidence Bag: soiled archival gloves, 2012. Photo by Jesse Vasquez.

2. Victor Hernández Cruz, *Maraca: New and Selected Poems 1966–2000* (Minneapolis: Coffee House Press, 2001).

3. In an official letter to Con Sapos director La Stef, the researchers employed the politically neutral term "fluid" to describe the carefully, if unchronologically, conserved remains. Thus, they concluded, a new team of "true archaeologists" would relieve them of their duties, imposing a standardized order and restructuring the entire Con Sapos collection to make it translatable to institutionalized preservationists and museum-goers alike. Con Sapos has, however, resisted all such invitations, opting instead for questionable preservation conditions (due to budget restraints) that ensure the maintenance of their nonlinear categorization.

In fact, Miss Ella first utilized the antiquated technology to bolster Con Sapos membership with, of course, the expressed permission of all RCAF members. In total, we were able to enlist the additional services of historians John Rollin Ridge, Giorgio Vasari, Jean Charlot, and a handful of others. With the team's help, Miss Ella has been able to cross-reference carbon-dated skin cells with measured levels of light intensity left by the gradual bleaching of color in certain places to identify exactly who had crossed over and back, and for how long they stayed in their alternate worlds. Compilots Lorraine Garcia-Nakata and Rudy Cuellar hold the record, but other guests have included the United Farm Workers Union's own Dolores Huerta, philosopher and educator José Vasconcelos, and beloved Nuyorican poet Victor Hernández Cruz, who celebrated the adventure in a series of robust stanzas dedicated to the pilots.[2]

Western researchers have long disregarded Con Sapos' typological distinctions, deeming the team's categorization methods unfit for pure scientific purposes.[3] As a partial consequence, Miss Ella's landmark find has yet to be published in book form. However, her important addition to what we know about the capital city is quickly becoming written into local historical brochures available throughout Old Town.

AN EXCEEDINGLY SMALL
SAMPLING FROM THE
ORAL VAULTS

Upon conclusion of an oral history
interview with Stan Padilla, I found
the tapes completely empty with no
plausible cause. I had run equiptment
tests and sound checks as in every other
interview.

I have never told Stan Padilla this.

Fig. 79. La Stef, Index Note #16:
Stan Padilla tapes, 2008. 3" × 5".

The RCAF is sexist. There was no space for women in the RCAF. The RCAF was unwilling to embrace women's rights while demanding ~~civil~~ rights for Chicanos. The sexism exhibited by the RCAF is complex. Women were integral to the RCAF. There were many women in the RCAF. Women secured funding, wrote grants, organized events and took care of the basic functions that made the RCAF possible. Women were artists in the RCAF. There was space for women in the RCAF. The RCAF is not sexist.

Fig. 80. La Stef, Index Note #17:
Sexism in the RCAF, 2011. 3" × 5".

"...the RCAF beca
La vida loca was
and this served a
flames of passion
'60s and '70s. Ye
was the raza's fi
race, ushering in
exploration, when
RCAF's top secret
now known as the
only reenter eart
ing up because of
ceramic tiles."

...ing
it seemed
lot and what we cou

Steve LaRosa: Your path once crossed, directly or indirectly, with the FBI, the Symbionese Liberation Army and a pack of tortillas. What was that all about?

Jose Montoya: Imean, if we were dangerous, we were probably more dangerous to ourselves than we were to the system.

Steve LaRosa: Alright. Let me ask you this: these guys, lot of them came and a lot of them stayed, and a lot of them moved on. What was it about them that seemed to form

Fig. 81. Untitled
(Oral Vault #1), 2011.

Fig. 82. Untitled
(Oral Vault #2), 2011.

ent of chicanismo.
the vida cosmica,
that burst into
protest in the
wning achievement
ution to the space
era of NASA space
on learned of the
e adobe airplane,
le - which can
here without burn-
tive shield of

uis Valdez

"It's kind of sad and unfortunate,
Sacramento. You heard of the Big
Apple? Well, there is a Big
Tomato here and we seem to be
spending too much time with
pedantic encounters here as to
whether to allow art to come in
in such massive doses, you know.
And I am one to believe that
Sacramento cannot OD on art."

-General Esteban Villa
after his arrest for
attempting to repaint
the whitewashed murals
on the Sacramento
State University campus

Fig. 83.
Untitled (Oral
Vault #3), 2011.

Steve LaRosa: I think of the
Magnificent Seven when he col-
lected a bunch of rag-tag guys
from different backgrounds that
when they came together as a whole
were able to affect some really
worthwhile change. Tell me about
what was going through your mind
when you started recruiting this...

Jose Montoya: I think that's the
whole misconception that people
have that we went out and looked.
You couldn't have done that. There
is no one who has those organizing
abilities...We had an opportunity
to right some wrongs. Now I think
of the Chicano Movement. That's
called empowerment. When we felt
it, it scared the living shit out
of us because it seemed to demand
an awful lot. As we moved into the
Chicano Movement, we heard very
clearly that there was a role for
everyone and that if we were good
at plumbing, the Movement needed
plumbers. If there was someone who
could write, the Movement needed
people who wrote. And we just stay-
e d in the background until some-
body said, "and artists, what artists
can do..." Iheard it as clearly as
everybody else. We were going to do
for the Movement.

Fig. 84.
Untitled (Oral
Vault #4), 2011.

Esteban Villa: There's a lot of
insinuation that we're not taking
(art) seriously, so it spills
over into cynicism, sa

Fig. 85.
Untitled (Oral
Vault #5), 2011.

THE ANCIENT DOCUMENTARIES OF SOUTHSIDE PARK

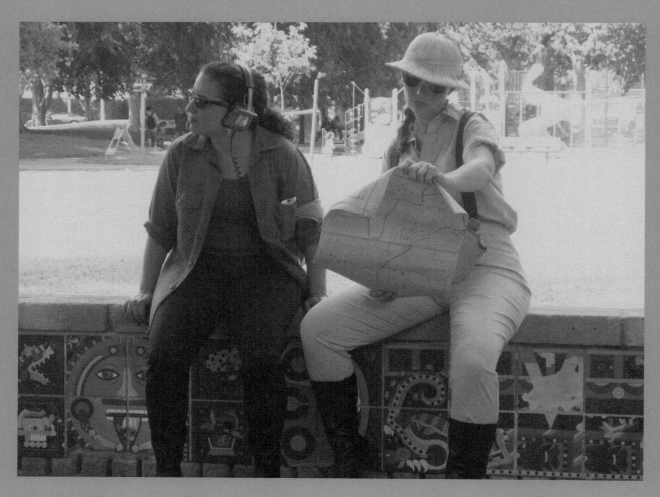

Fig. 86. Janell Lacayo, La Stef and
Miss Ella at Zapata Park. © 2010 Janell
Lacayo. Courtesy of Janell Lacayo.

N EAR THE END of the Fourth Sun, when the world was about to split open and make way for the Fifth, members of the Royal Chicano Air Force, informed by scholars and elders, reinvigorated a series of ancient ceremonies, including Día de los Muertos, Fiesta de Tonantzín, Fiesta de Colores, y Fiesta de Maíz. The freestyle interpretation of the sacred rites infuriated some indigenist activists engaged in more authentic reenactments, but the RCAF and their comrades continued with their belief in the greater need. The organizers had been informed by Dr. Arnaldo Solís, who in his own sociological research had come to the hypothesis that certain cultural and historic wounds that plagued the local Chicano community and continued to cause ingrained psychological, spiritual, and even economic damage could be healed in part by updating and reinstating ancient cultural ceremonies that both marked individual rites of passage and affirmed and connected one in a positive way to the whole of one's cultural history. He wanted to test this hypothesis, and the RCAF was ready. (Comandante Montoya had even warmed up to the idea of indigenous spiritualism having a place in the Chicano Movement.)

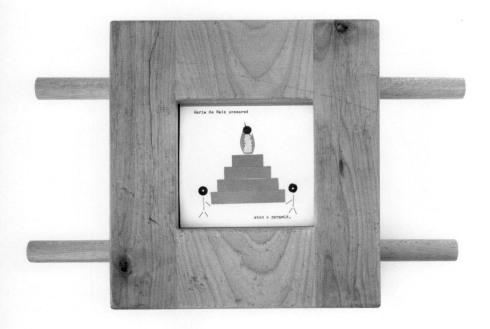

Fig. 87. Fiesta de Maíz sacred scroll, 2010. Photo by Jesse Vasquez.

The Sacramento Concilio, led by Josie Talamantez, Terezita Romo, Rosemary and David Rasúl, and others, took on the strategic planning for the ceremonias, including the securing of required legal permits and fundraising. For Day of the Dead, they even chartered a flight to Mictlán to extend personal invitations to key ancestors and submit a request for sacred visions from Mictlantecuhtli and Huitzilopochtli without the need for sacrificial cannibalism, which they reasoned would complicate the already controversial use of public space with too much illegality.

Others, including Privates Stan Padilla, Gina Montoya, and Juanishi Orosco, prepared a sweat lodge on Stan's property in the Sierra Nevada foothills—a place believed to house potent spiritual energy, as well as being the site of historical atrocities associated with the European discovery of gold and other minerals. The group gathered green willow branches, pine resin, and stones in preparation for the cleansing.

Fig. 88. Fiesta de Tonantzín (missing scroll), 2010. Photo by Jesse Vasquez.

The following narratives describing the first ceremonies held in Sacramento were recently excavated from the Southside Park cenote by La Stef and Miss Ella. A major find in the field of RCAF scholarship, three of the four sacred scrolls were found encased in wooden boxes with cutout holes for viewing. Read from top to bottom by turning the handles, it is not unlike watching film in a prehistoric television set. Indeed, it has been confirmed that these Ancient RCAF Documentaries are the missing link between the ancient scroll book form and contemporary film media, proving that they are indeed the precursor to movies and television. Thus, it can be concluded that these dominant forms of art and entertainment have originated entirely in the Americas.

There was no physical record found of the Fiesta de Jaguares, a ceremony said to have been developed by danza azteca leader Chuy Ortiz to honor and establish a rite of passage for young men.

While a fourth box was found in pieces, the scroll pertaining to Fiesta de Tonantzín was missing.

THE FIRST DÍA DE LOS MUERTOS EN SACRAZTLÁN

Fig. 89. Día de los Muertos sacred scroll (panel 1).

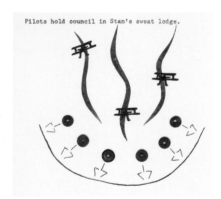

1. Pilots hold council in Stan [Padilla]'s sweat lodge

Fig. 90. Día de los Muertos sacred scroll (panel 2).

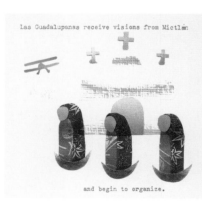

2. Las Guadalupanas receive visions from Mictlán / and begin to organize.

Fig. 91. Día de los Muertos sacred scroll (panel 3).

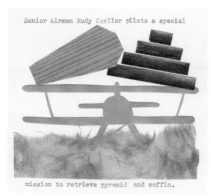

3. Senior Airman Rudy Cuellar pilots a special / mission to retrieve pyramid and coffin.

Fig. 92. Día de los Muertos sacred scroll (panel 4).

4. Chuy's danzantes lead procession down 64th / to the cemetery,

Fig. 93. Día de los Muertos sacred scroll (panel 5).

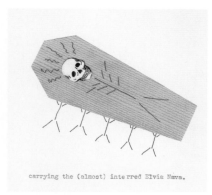

5. carrying the (almost) interred Elvia Nava

Fig. 94. Día de los Muertos sacred scroll (panel 6).

6. The neighbors complain.

Fig. 95. Día de los Muertos sacred scroll (panel 7).

7. Finally, they arrive at the cemetery.

Fig. 96. Día de los Muertos sacred scroll (panel 8).

8. They offer blessing at the four directions. / In reverse.

Fig. 97. Día de los Muertos sacred scroll (panel 9).

9. Las Mujeres perform an interpretive "Birth Dance."

Fig. 98. Día de los Muertos sacred scroll (panel 10).

THE FIRST FIESTA DE MAÍZ

The First

Fiesta

de

Maíz

Fig. 99. Fiesta de Maíz
sacred scroll (panel 1).

1. Held on the summer solstice / with the sun at its zenith

Fig. 100. Fiesta de Maíz
sacred scroll (panel 2).

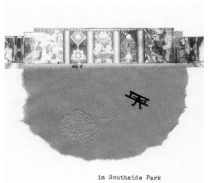

2. in Southside Park

Fig. 101. Fiesta de Maíz
sacred scroll (panel 3).

3. where / a few / months / prior / . . .

Fig. 102. Fiesta de Maíz
sacredscroll (panel 4).

4. a visiting Tibetan monk / discovered a crystal bed

Fig. 103. Fiesta de Maíz sacred scroll (panel 5).

5. beneath the pond / that was really a cenote

Fig. 104. Fiesta de Maíz sacred scroll (panel 6).

6. that had a vein that ran / from SacrAztlán all the way to Hopi.

Fig. 105. Fiesta de Maíz sacred scroll (panel 7).

7. When the elders arrived / they burned copal.

Fig. 106. Fiesta de Maíz sacred scroll (panel 8).

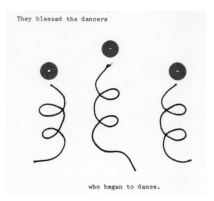

8. They blessed the dancers / who began to dance.

Fig. 107. Fiesta de Maíz sacred scroll (panel 9).

9. They / danced / . . .

Fig. 108. Fiesta de Maíz sacred scroll (panel 10).

10. and / they / danced

Fig. 109. Fiesta de Maíz
sacred scroll (panel 11).

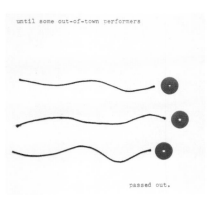

11. until some out-of-town performers /
passed out.

Fig. 110. Fiesta de Maíz
sacred scroll (panel 12).

12. Maria de Maíz appeared / atop a
pyramid.

Fig. 111. Fiesta de Maíz
sacred scroll (panel 13).

13. Xilonens—dressed in white— / enter
the sacred circle.

Fig. 112. Fiesta de Maíz
sacred scroll (panel 14).

14. They receive the blessings and the
palabra.

Fig. 113. Fiesta de Maíz
sacred scroll (panel 15).

15. They had prepared all year for this.

Fig. 114. Fiesta de Maíz s
acred scroll (panel 16).

Fig. 115. Fiesta de Colores
sacred scroll (panel 1).

1. The first ceremony / of the yearly cycle

Fig. 116. Fiesta de Colores
sacred scroll (panel 2).

2. is held on the spring equinox / with the world in bloom.

Fig. 117. Fiesta de Colores
sacred scroll (panel 3).

3. Pilots cleanse themselves and create / a sacred circle in Zapata Park.

Fig. 118. Fiesta de Colores
sacred scroll (panel 4).

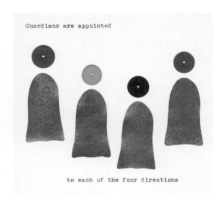

4. Guardians are appointed / to each of the four directions

Fig. 119. Fiesta de Colores sacred scroll (panel 5).

5. to craft / altares y / palabras / to reflect / their / essence:

Fig. 120. Fiesta de Colores sacred scroll (panel 6).

6. North / Antepasados. The passing of life

Fig. 121. Fiesta de Colores sacred scroll (panel 7).

7. East / Men

Fig. 122. Fiesta de Colores sacred scroll (panel 8).

8. South / Children

Fig. 123. Fiesta de Colores sacred scroll (panel 9).

9. West / Women

Fig. 124. Fiesta de Colores sacred scroll (panel 10).

10. Dressed in their finest huipils / and street clothes,

Fig. 125. Fiesta de Colores sacred scroll (panel 11).

11. they pass out pamphlets /describing the rites

Fig. 126. Fiesta de Colores sacred scroll (panel 12).

12. and lead a group of children / from the Breakfast for Niños program

Fig. 127. Fiesta de Colores sacred scroll (panel 13).

13. around to each station / for consejos.

Fig. 128. Fiesta de Colores sacred scroll (panel 14).

THE RCAF IN SPACE

AS FELLOW Con Sapos member Erich von Däniken concluded in his studies of the ancient Andean mountainside candelabra, the airstrip guided spacecraft two hundred miles away to the spaceport at the Plain of Nazca in present-day Peru. He went on to find a second landing strip in northern Chile. As I. J. Gallagher observes in his 1977 publication, *The Case of the Ancient Astronauts*:

> Von Däniken heard of another giant figure in Chile. This was a 330-foot-high robot, outlined in volcanic stones. The robot's body was rectangular and its legs dropped straight down. Its thin neck supported a head with 12 antennae. From hip to thigh, triangular fins (like wings of supersonic fighters) were attached to the body on both sides. Was this robot made by men? Some experts believe it was the work of beings from another planet. How would ancient artists know what a robot looked like? Was the robot an ancient astronaut in space clothing?

These and other questions have been answered in Con Sapos' careful analysis of the contents of the Oral Vaults. We have uncovered numerous accounts of the RCAF's use of the landing strips to guide their spacecraft back to earth. How the ancient artists knew what a robot looked like can be found in the fact that

RCAF ASTRONAUTS*

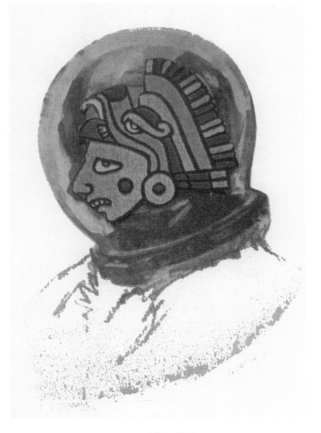

Fig. 129. RCAF Astronauts, 2010. Photogravure printing by João Sánchez.

* A Note from Con Sapos Regarding Spacecraft Pilots:

Trained by various RCAF pilots in the Peer Mentorship Programs and in academies not necessarily in alignment with the group's own philosophies, one may note that a defining factor of the contemporary RCAF astronaut is a perceived lack of allegiance—either in learning phases or as a lasting state of operation. Whether desired or fought against, these migratory patterns particular to young pilots are the result of attempts to bridge disparate fields of research and analysis in order to survive the non-space they must ultimately navigate.

While some in the ranks refuse to accept this kind of impure allegiance to the RCAF's original guiding pedagogies, some leaders do recognize this need of the young astronauts to untangle their teachings and reorganize them in collaboration with the more fluid properties of contemporary aeronautics.

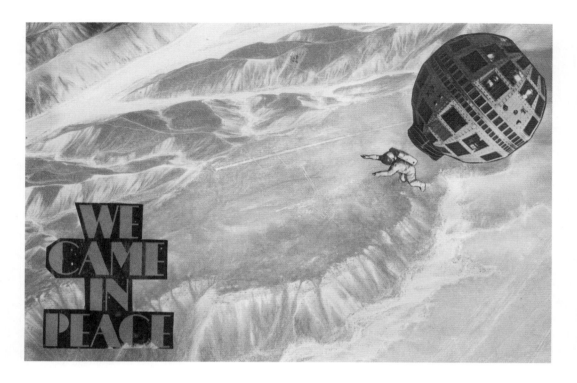

Fig. 130. Single remaining panel from an RCAF Astronauts promotional brochure. From the colleciton of Con Sapos.

RCAF astronauts not only uncovered ways to move through space, but also through time. Sergeant Stan Padilla led the elite squadron's temporal crossover missions, preparing the astronauts with cleansing sweats in the middle of winter in a lodge nested in the Sierra Nevada foothills. It is imperative, he maintains, to cleanse travelers before their journey so as not to carry foreign energies into the different temporal frames they would enter. This, he said, could have major repercussions on our ideas of past and present.

After purification, the astronauts suited up in custom regalia made with only the finest weave of peyote fibers encased with a protective layer of clay gathered from the South Yuba River watershed. Major Padilla, Dr. Arnaldo Solis, y La Señora Cobb oversaw the final blessing, details of which must remain undisclosed, but suffice it to say it has something to do with cempaxochitl petals and a procession through St. Mary's Cemetery.

WITH THE help of veteran Wintu singer-elder Frank LaPena, the Royal Chicano Air Force's elite team of astronomical engineers designed the first lunar module, inspired in part by the simple aerodynamic qualities and cosmological significance imbued into the roundhouse structure indigenous to the Sacramento Valley and surrounding foothills. The team held dances and meetings in search of materials that would complement the structure and hold up to the elements of non-space. Employing, of course, adobe for the major portions, they also were guided to construct bricks of sand for additional heat resistance. They scoured their workshops for finishes and settled on a lacquer coating with ethyl cellulose ink and vinyl paints for the insignia. For landing gear, the engineers installed ocotillo cactus limbs for their ability to withstand extreme temperatures and their unparalleled absorption of solar energy.

TRANSLUNAR INJECTION

The module was originally designed to enable the landing of troops and participants to march for the equal rights of interplanetary workers employed to lay the foundation for future lunar living of Earth's middle- and upper-class intergalactic pioneers. Bringing with them a collapsing capitalist model, the interplanetary workers' strike seeks to ensure fair treatment, adequate housing, and oxygen supply, and to ensure the discontinued use of the short hoe.

THE LUNAR MODULE

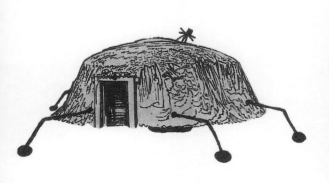

"By the beginning of the eighteenth century it was universally accepted in America that the Indian was the descendent of the lost Tribes of Israel...Centuries of repetition (with explicit theological approval) and this theory — resisting the assaults of logic — had hardened into anthropological fact."

— Victor Wolfgang Von Hagen

Fig. 131. Lunar Module, 2011.

Fig. 132. La Stef, Index Note #18: Lost Tribes, 2011. 3" × 5".

BIOGRAPHIES

IN THE anthropological practice of biographical documentation, it is not the single life that is of interest, but rather how an individual life might inform what we know of its socio-historical context.

Consider, for example, the following biography of the Royal Chicano Air Force's most canonized leader, José Montoya. [To illustrate, several historical contexts to which the narrative of his life point have been made graphic.]

Fig. 133. La Stef, José Montoya Biography, 2011. 3" × 5".

'Dust Bowl' migration to California by poor farming families during the Great Depression

Rural New Mexico 1930s & 1940s

Segregated education of Mexican-American students prior to Mendez v. Westminster

Sleepy Lagoon murder trial

Increase i advanced education minorities

Oakland Housing Projects

The story Jose Montoya tells in varying forms in varying sequences to varying interviewers about how he came to fine art has to do with the following events: a) growing up in abject poverty during the Great Depression in rural New Mexico b) moving with the crops in a farmworking family out to California c) being put into "MR" classes where he learned to draw using "funny books" and pulp Western covers as models d) practicing body art on himself and his older brothers because he knew how to get black India ink and a needle from the cactus e) becoming the yearbook illustrator for his high school f) being drafted into the US Marines for the Korean War after getting into "some trouble" g) being rejected by the Marines for having the same "gang symbol" as the pachucos who beat up sailors during the Zoot Suit Riots - he subsequently turned the cross on the flesh between his thumb and index finger into an anchor to avoid an alternate punishment h) pushed for an education with his GI Bill of Rights when officials steered himtoward trade school i) was accepted to the California College of Arts & Crafts

The following is a sampling of biographies of the personalities related to the Royal Chicano Air Force who make an appearance of one kind or another in this book. It is by no means a comprehensive listing.

La Virgen de Guadalupe has been making guest appearances on everything from cathedral walls to low riders since 1648 after reconstructive surgery sponsored by the Catholic Church. Formerly known as Tonantzín, La Virgen is responsible for countless acts of divine intervention, as well as the sanctification of the world's first fully indigenous saint, our beloved Juan Diego. Known also as La Reina de Las Americas and Lupe, the Virgen can be seen walking down T Street between the hours of 3:00 a.m. and 6:00 a.m., Monday through Saturday.

Element: Roses

Dirección/Punto Cardinal: Hacía adentro

José Guadalupe Posada (1852–1913; 1930–1939; 1968–present) produced some twenty thousand prints as a paid illustrator for a commercial shop owned by Sr. Vanegas Arroyo. Reimagining indigenous philosophies of life as dream and the calavera image as playful, Posada pointed to death as the great equalizer. He poked fun at inflated politicians, the overfed bourgeoisie, and the peasants who purchased his broadsides for one peso each. Thus, as he made a profit off every market, Yanqui intellectuals consider it cutting edge today to reposition Posada as a capitalist. Artistic incarnations, though, have argued him otherwise. First reappearing with the transcendental guidance of Jean Charlot, Posada-as-muse made an appearance in "Dream of a Sunday Afternoon" by Diego Rivera, a later capitalist-communist artist of cubist training and indigenous American fresco leaning. Posada was also said to grace the linoleum and lacquer of such noted figures as José Clemente Orozco, Leopoldo Méndez, and Dr. Atl (Gerardo Murillo), positioning Posada as a potent revolutionary artist in the eyes of subsequent generations, which is all that matters in historical accuracy anyhow. The spirit that escaped Posada every December when he took his annual leave of exactly one month to rest is documented to have fled back toward the original homeland of his ancestors, located approximately on the corner of N and Folsom in SacrAztlán. (In actuality,

legal documentation for his journey al Norte was never obtained but orchestrated instead by low-profile coyotes Josie Talamantez, Armando Cid, and Vanegas Arroyo's own grandson. Vigilante forces along the US-Mexico border are currently tracking his soul with the use of heat-sensitive combat robots developed for use in Iraq and purchased for private use by the Minutemen Project. Their efforts as of yet, however, have been unsuccessful.) Upon arrival, his esoteric sensibilities were given carnal shape by Louie "The Foot" González's novel use of silkscreen techniques and color. Terezita Romo stayed in charge of field notes.

Armando Cid has said of J. G. Posada's impact: "Posada was the foundation for the political philosophy of indigenous people and that we could laugh at ourselves . . . [La Raza Bookstore's exhibit of Posada prints] put us on the map in the north. It also solidified our grants."

An RCAF member has been recorded as saying of Cesar Chavez: "Cesar, no matter what he had to do that was important in terms of the lobbying or the legislative work of the UFW [United Farm Workers] Union or whatever, he always made it a point to come to the Centro [de Artistas Chicanos]. He was very intrigued with the operation of reproducing images. The idea, the silkscreen process. It fascinated him. He pulled his share of squeegees for us as he told us his sea stories, we used to call them. He was in the Navy, you know."

When in the company of his Air Force officers, Cesar Chavez went by "Chief" or "The Little Guy." It is on record that he was buried with a toy adobe airplane atop his simple pine casket.

Four-Star General Esteban Villa, who is not subject to discipline, has said:

"After having worked in the San Joaquín Valley, I can do anything."

"A wall is like a page out of a book. It's very important."

Unlike most humans, General Villa is made of the kind of flesh that does not slough off in his daily happenings, which is why at his home there is 80 percent less dust accumulation than in any and all homes across the neighboring suburbs. On the contrary, the skin enclosing Gen. Villa's other organs has become a fortified accumulation of cellular growth, compressing itself as such until it allows no penetration by foreign bodies. It is for this reason that General Villa is the only member of the RCAF who does not require the woven maguey armor characteristic of the group and is often used as a detractor in hypo-legal operations by both the Air and Naval Forces, a trait attributed to his exposure to the atomic bomb testing at the Bikini Islands while serving in the United States Navy.

José Montoya, referred to alternately as Field Marshall and Supreme Allied Commander, among other names, has said:

"We had seen what assimilation and acculturation had done to the WWII veterans who went to colleges and became Mexican-Americans. Very little Mexican left."

"Chicano art was so new that our egos weren't yet full blown. It was about cultural work, not about art."

"Now the other thing that I know had a large influence in our behavior was that we were all a little bit crazy."

"The creative juices of the artist and the utilitarian needed to make things available were very well welded together to produce the kinds of posters that have made the RCAF famous in that area of poster making."

"My story conflicts with other stories I've heard."

When Comandante Montoya opens his mouth to make sounds, it is said that if you look closely, you can see the formation of flowers inside his throat. [Archivist's Note: To prove this popular theory, a conclusive CALLA scan was run on Montoya while in song, revealing not only the

formation of xochitl flowers, but the congealing of star matter as well. To what this can be attributed, the technologies of our outsourced laboratories are not yet equipped to define. However, contact with the famed sorcerer Merlin—who has relocated at least three of his temporal bodies to Los Alamos National Laboratories—has revealed that this phenomenon could be due in large part to the fact that Montoya's entire molecular structure is composed of suspended particles of fire opal and petrified cosmic matter. Thus, he concludes, Montoya is an original descendant of the Evening Star, combined with enough fermented maguey sap to render him among the realm of humans.

Another thing said (by Juan Manuel Carrillo) of José Montoya: "José became the focal point for the world to look at the RCAF and for us as he connected to the world. It's not to say that José's ideas are always our ideas."

Until his death, José Montoya was at work on a book titled *How I Came to America*.

José Montoya was born in rural New Mexico.

Ceremonies for Armando Cid (1943–2009) on July 19, 2009, began with "ritual dancing by local danzantes followed by a traditional church service at 2:00 p.m . . . followed by a color guard service," as reported by the California Arts Council. Col. Cid lived in a body composed of 103 percent Nova paints, 43 percent nontoxic serigraphy ink, 26 percent teaching genes, and 78 percent heart matter. Wherever he wandered, the colors would splash out of him and land impressively on walls, sidewalks, and even other citizens. It was a condition he could not contain and, being such, it was for this reason that the Sacramento neighborhood in which he resided, Alkali Flats, was first filled with color. Using the recently signed Americans with Disabilities Act as a foundation, his lobbying efforts of the neighborhood and city councils led to the successful implementation of the City of Sacramento's Art in Public Places Program, which ensures a percentage of public space be dedicated to the arts. As a result, his Ollín and Sunburst murals on the sides of the Zapata Park Housing Project

(now the Washington Square–Sherwood Apartments) became the first commissioned public art piece in the city. His work set a precedent for the City of Sacramento, which quickly became one of the nation's most colorful urban landscapes.

For years, subcomandante Ricardo Favela (1945–2007) stayed in search of the elusive Mr. Con Safos. After a successful search-and-retrieve mission, he exhibited the remains at California State University, Sacramento. He was careful to keep a minimum of two silkscreen posters made during every early RCAF run. Favela eventually turned over an extensive private collection of RCAF prints to the Sacramento State University archives.

Ricardo Favela was responsible for the longevity of the RCAF's Barrio Arts mission, an interplanetary collaboration between Sacramento State University and the Washington Neighborhood.

Rudy Cuellar never drank. He has, however, demonstrated a lifelong fascination with pyrotechnics. Of the Royal Chicano Air Force's involvement with the United Farm Workers Union, he has commented: "Oh, it's nice to work with the Union. We're always ready. We're like—what do you call it?—25 hour service." Of Sacramento, California, he has said it was a "Little Paris for Chicanos in those days."

There are seventeen conflicting accounts of how Louie "The Foot" González—silkscreen artist, squeegee art master, concrete poet— earned his name. None of them have to do with the fact that he led the flag brigades for the United Farm Workers Union, even for Cesar Chavez's funeral. Nor with his statement that "an unused frame is just taking up space, so I just combine that with unused words."

He has also said: "Sometimes Chicano art is predictable, more the same."

Juanishi Orosco grew up in a farm-working family in Rancho Cordova near Stan Padilla. He does not recall having met Stan Padilla in childhood, but does recall having first met Juan Carrillo in yoga class. Juanishi was the instructor of said yoga class.

In the Pentagon's declassified documents from the Vietnam War, it is noted that retired RCAF Captain Nezahuacoyotl intervened on Juanishi's behalf, petitioning for an immediate honorable discharge and safe return to California. The 101st Airborne Division flight carrying Private Orosco was informed during their inaugural flight to Vietnam that the war had been called off. The exact price tag for Captain Nezahuacoyotl's petition, however, remains undisclosed.

Juan Manuel Carrillo has written of Juan Manuel Carrillo, Tamazultepec: "Born in 1941, 1965 and 1979. Died once. Educated in very weird places at times. Able to leap tall mounds of grant applications. Son of Maria Carmela Guerrero and José Ygnacio Carrillo. Wed in holy matrimony to Adalina Hernandez. Sons: John, Miguel, Diego, Adan y Ivan. Member, RCAF. Love travel, good music and good food. Religion: most of my life. First employment: delivering the San Francisco News. Last employment: maybe tomorrow."

After living for ten years off the land in Washington, Lorraine Garcia-Nakata grew tired of the taste of peas and enrolled as a student at California State University, Sacramento. She makes a point of noting that she was first introduced to members of the Royal Chicano Air Force through her older brother, Carlos Olivas, who worked at a campus media center. She has been recorded as saying, "When you looked at what [museums] exhibited as contemporary art, pretty much there was never anything in terms of Latino artists, Black artists that are new. So in the early years, people were pushing that margin and they were saying, well, there's art and there's this other. And we were saying, no, no, we're not the other. We're part of the contemporary scene, you just happen not to know about it."

It has been revealed through an unauthorized full-body scan that Stan Padilla has crystals growing inside his heart cavity. Records show Stan having negotiated that, upon his eventual passing, he shall return to the state of Stone Being from which he originally emerged.

Stan Padilla describes the RCAF's *la locura lo cura* mantra as an embodiment of the Sacred Fools philosophy.

Enter Max Garcia. Exit Max Garcia. Enter Max Garcia. Exit Max Garcia.

All known photographs of Max Garcia show him with a paper bag over his head. It is spoken that Max, the artist, is color-blind and yet created one of the most extensive color charts any of the group's muralists had ever seen.

Clad in full Royal Chicano Air Force regalia, Irma Lerma Barbosa is the only pilot to hold double rank—her other position being a commander of Las Comadres Artistas collective. She has written of her own service in the Air Force: "Viva La Raza! Venceremos! Ajúa! faded to an echo of a sigh. . . . Deep within, however, there remained a spark and a voice that spoke firmly in the dark / 'Cover your broken parts with strong symbols', it told us. / 'Let them lie where they fell, it is only justice, / Lift your soul, Toss your burdens aside / Become one with the whole where the sky divides.' / So I tossed aside the straps and the boot and joined the R.C.A.F. in one more salute."

One unfamiliar with life in so-called "cultural borderlands" might assume Juan Cervantes' conscious choice to remain Mormon would impede his involvement with the at-times-infamous Royal Chicano Air Force. And while some might attribute Cervantes' lifelong commitment to teaching, community work, and artistic activism to the moral superiority said to be unique to all sanctioned religious denominations, it is a commitment shared by all members of the RCAF. Cervantes is, however, rumored to have sold his own blood to finance the creation of a book of poetry.

RCAF Band Leader Freddy was a Vietnam War veteran. Others recall: "His stature, being small put him in situations in Viet Nam that were pretty horrendous." When he returned, he served as a Brown Beret unit leader in Sacramento. He later went on to produce the Chicano rock opera, *Xicindio*, with other RCAF Band members.

Josie Talamantez and Armando Cid are credited with reviving the nearly forgotten corpse of José Guadalupe Posada after the body had been smuggled across the US-Mexico border by Arsacio Vanegas. Talamantez is also credited with having helped organize the creation of Chicano Park in San Diego and an important RCAF mission to the site, the results of which are still on view in the now-famous park.

Rene Yáñez is imbued with the power to be in multiple places at once, including across space and time. He is one of the only living members able to crack Royal Chicano Air Force Morse Code.

Carlos Licón emerged from Mother Earth an entire sun ahead of the founding members of the Royal Chicano Air Force, but left numerous traces of color for the pilots to follow in their search for a landing strip.

Former Sacramento mayor Joe Serna, Jr. provided the Royal Chicano Air Force with its first official hangar, which also doubled as the astute politician's garage. The Sacramento chapter of the United Farm Workers Union and the fledgling Chicano Organization for Political Awareness (COPA) were also housed in his garage-turned-headquarters during the Movimiento.

Terezita Romo pioneered the field of RCAF art historical documentation when she enlisted as a young student. Her records now serve as source materials for Con Sapos' in-depth recovery and analysis projects. Romo was also responsible for securing countless grants in support of RCAF community service projects, as well as helping to organize those projects.

Juanita Polendo Ontiveros is the only pilot officially sanctioned by the Royal Chicano Air Force to crack enemy codes and, as such, is sent in on all undercover missions. Polendo Ontiveros is also the only pilot certified to deliver babies mid-flight and to fly La Espina del Maguey, a special RCAF aircraft that carries sewing machines used in the production of huelga flags. She is rumored to have been involved in several cornfield raids to feed picketing farmworkers.

Someone has said about the Royal Chicano Air Force: "When I met the guys, it was like soul life. I'd come back from a divorce, come back from Vietnam, and no one would hire me as a veteran . . . They gave me back my spirit."

Founded by self-taught aeronautical engineer Gilbert Gamino, Aeronaves de Aztlán is the official RCAF repair shop notorious for putting the wrong engines back into the troop's aircraft. This never happened when they were working on Cesar Chavez's machine, however.

The Reno Club featured an early mural painted by Armando Cid and took up residence at the twelfth block of D Street in Sacramento's Alkali Flats near Chalinsky's Tacos. It was home to important RCAF meetings, called "Cantos." Posters for the "One More Canto" events attest that attendees included: raúlsalinas, Lucha Corpi, Antonio Burciaga, Juan Felipe Herrera, José Montoya, and Alurista, among others. Upon the club's demolition, Comandante Montoya erected an altar.

On the antiquarian "improver":

"Sculptors would decide that if the ancient artist had not practiced certain principles of design and craftsmanship that he should have, and it was up to their own more enlightened age to correct these shortcomings...no hesitation in hacking away at an ancient masterpiece until its own creators would scarcely have recognized it."

Fig. 134. La Stef, Index Note #19: The Antiquarian Improver, 2007. 3" × 5".

AFTERWORD

IN THIS collection, there are very few "real" archives. There are two reasons for this: the first has to do with restrictions set forth by the controversial US copyright law, which aims to protect artists' rights to their intellectual property. The second is because I have become a character of suspect among some holders of said property rights.

This is not a colonial fantasy in which I forsake my cultural inheritance in order to prove my allegiance to an indigenous noble savage population and then report back to you, dear reader. This is my cultural inheritance. This is the United States of America and we are messy. We are open systems bumping into one another, swapping historical memories and ingesting collective narratives. The lines between you and I have never been so clearly defined as my parents and grandparents or your parents and grandparents have led us to believe. They are not so hardened as those who do not like me on principle would like them to be. I am broke open and bleeding, and so are you. And still we are so afraid of losing some precious sense of identity that we cannot even bare to look at one another. Not really. We, your greatest nation in the world, are still a colony. And we will continue to stagnate until we can make a mess, until we can let go of our tidy, well-crafted stories long enough to not pretend to know who or what we are. Long enough to risk our own outworn sense of identity.

So I am letting the myths take over where truth has become privatized. They are so very different, I am told.

Chicano \chi-'kä-(')nõ\ *n, pl* -nos [orig. *mejicano* Mexican]: an American of Mexican descent—Chicano *adj*

Chicano \chee-'kah-no\ : Joaquín Murrieta

Chicano \Rez-ees-ten-see-ah\ *v, pl*: "What keeps us viable is the memory. And it's that memory that people are trying to eradicate."

Hispanic \high-spa-nic\ *n, pl* -nunca [orig. *José Montoya*]: "I resent someone labeling me in a way that leaves out part of me."

Chicano \shi-'käh-(')nõ\ *n, pl* -nos [modif. of Nahuatl *mexica*]: immigrant in one's own land

Chicano \chee-'käh-(')nõ\ *n, pl* -nos [orig. *The Foot*]: an insistence to exist

Chicano \xi-can-o\ [of *Ruben Salazar*]: 1. "A Mexican-American with a non-Anglo image of himself" 2. [Salazar] Journalist shot in the head at short range with a tear gas projectile by a member of the Los Angeles Police Department while seated in the Silver Dollar Bar during the National Chicano Moratorium March against the Vietnam War. A coroner's inquest ruled the shooting a homicide, but the police officer involved, Tom Wilson, was never prosecuted.

Chicano us them us them us them us them us them us them us them us them they we

Chicano \chi-ca-no\ *n, pl* -n@s [orig. *Esteban Villa*]: I'm an American by birth and a Chicano by choice . . . anybody can be Chicano because it's accepting a philosophy.

Chicano \chi-ca-no\ *v, pl* -el pueblo, la raza [modif. Of Nahuatl *mexica* Mexica]: 1a. The Dog People journey through Aztlán b. Manifestation of prophecy at Tenochtitlán 2a. La Conquista and/or Reapparition of Quetzalcoatl 2b. La Revolución 3a. The Treaty of Guadalupe Hidalgo,

```
pedici /ped-ee-chee/ (of Arabic origin,
  fr. pedir) m: 1: a phenomena plaguing
  creative types engaged in community
  activism, whereupon output is expected
  upon demand and without monetary
  exchange 2: thirty years of giving
  away posters that now derive high
  monetary and cultural capital 3: topic
  of many conversations over draft beers
  at Simon's  5: the RCAF's Medici
```

Fig. 135. La Stef, Index Note #20: Pedici, 2008. 3" × 5".

1848 3b. The Foreign Miners Tax 4a. Zoot Suit Riots 4b. The Great Repatriation 5a. The Lemon Grove Incident 5b. Walkouts 6a. The Chicano Moratorium 6b. Chicano Park 6c. Centros 7a. TBA [Under Construction]

Mexica : Mexicano : Mexican-American : Chicano : Xicano : Xicanindio : Xicana/o : Indígena

As is common among Con Sapos historians, it is impossible for me to document all source correspondences for this work, as much of the research conducted has been informal (i.e.: gleaned through non-academic human interactions and casual conversations that have not required release forms). These sources are specified as such throughout this book. The more formal—and thus academically sanctioned—interviews may be found here:

Tomas says to emphasize that the work of the RCAF was an expression organic to its social context.

In other words, the RCAF would not exist if it were not for the Movimiento.

Fig. 136. La Stef, Index Note #21: Tomás says, 2008. 3" × 5".

Alvarez, Jack. Interview with Stephanie Sauer. 2003. La Raza Galería Posada Collection, CSU Sacramento Archives.

Arrellano, Lucero. Personal Correspondence. December 31, 2003.
Barbosa, Irma Lerma. Interview with Maria Ochoa. Published in *Creative Collectives: Chicana Painters Working in Community* (University of New Mexico Press, 2003).

Carrillo, Juan. Interview with Steve LaRosa. July 24, 1994. Collection of La Raza Galería Posada as of 2004.

Carrillo, Juan, and Juanishi Orosco. Personal Correspondence. June 8, 2004.

Cid, Armando. Interview with Steve LaRosa. July 5, 1994. Collection of La Raza Galería Posada as of 2004.

————. Interview with Stephanie Sauer. July 23, 2002. LRGP Collection, CSU Sacramento Archives.

Cobb, Señora. Interview with Stephanie Sauer for La Raza Galería Posada. September 18, 2002.

Cuellar, Rudy. Interview with Steve LaRosa. July 2, 1994. Collection of La Raza Galería Posada as of 2004.

Diaz, Ella Maria. Personal Correspondence. November 11, 2008.

————. Personal Correspondence. June 23, 2010.

Dominguez, Francisco. Interview with Stephanie Sauer. August 19, 2002. LRGP Collection, CSU Sacramento Archives.

————. Interview with Stephanie Sauer. August 22, 2002. LRGP Collection, CSU Sacramento Archives.

Favela, Ricardo. Interview with Steve LaRosa. July 22, 1994. Collection of La Raza Galería Posada as of 2004.

————. Interview with Tatiana Reinoza. April 17, 2003. LRGP Collection, CSU Sacramento Archives.

Favela, Ricardo, José Montoya, and Esteban Villa. Interview with Stephanie Sauer. July 1, 2002. LRGP Collection, CSU Sacramento Archives.

Garcia-Nakata, Lorraine. Interview with Stephanie Sauer. March 13, 2004. LRGP Collection, CSU Sacramento Archives.

Goldvarg, Phil. Personal Correspondence. June 21, 2002. Fiesta de Maíz: Southside Park, Sacramento.

González, Hector. Interview with Steve LaRosa. November 22, 1993. Collection of La Raza Galería Posada as of 2004.

González, Louie "The Foot." Interview with Stephanie Sauer. February 13, 2003. LRGP Collection, CSU Sacramento Archives.

González, Xico. Interview with Stephanie Sauer. August 24, 2004. LRGP Collection, CSU Sacramento Archives.

Güereña, Salvador. Personal Correspondence with Stephanie Sauer for La Raza Galería Posada. 2002.

————. Personal Correspondence with Stephanie Sauer. Louie "The Foot" González's house. 2002.

Guererro, Zarco. Personal Correspondence. August 28, 2007. Giovani's Pizza, Chicago.

Huerta, Dolores. Interview with Steve LaRosa. July 1, 1994. Collection of La Raza Galería Posada as of 2004.

Johnson, Patricia. Interview with Stephanie Sauer for La Raza Galería Posada. May 4, 2004.

Luna, Art. Interview with Stephanie Sauer. July 9, 2004. LRGP Collection, CSU Sacramento Archives.

Mantecón, Arturo. Interview with Stephanie Sauer. April 26, 2004. LRGP Collection, CSU Sacramento Archives.

Montoya, José. Interview with Stephanie Sauer. July 26, 2002. LRGP Collection, CSU Sacramento Archives.

———. Interview with Stephanie Sauer. October 30, 2002. LRGP Collection, CSU Sacramento Archives.

———. Interview with Stephanie Sauer. June 8, 2004. LRGP Collection, CSU Sacramento Archives.

———. Interview with Steve LaRosa. November 5, 1994. Collection of La Raza Galería Posada as of 2004.

———. Interview with Stephanie Sauer. October 18, 2006.

———. Personal Correspondence with Stephanie Sauer. June 29, 2007.

Montoya, Malaquias. Interview with Stephanie Sauer. July 14, 2004. LRGP Collection, CSU Sacramento Archives.

Montoya, Tomás. Personal Correspondence. June 12, 2007. Round Corner Bar, Sacramento.

O'Neill, Sheila. Interview with Stephanie Sauer for La Raza Galería Posada. April 18, 2004.

Orosco, Juanishi. Interview with Stephanie Sauer. November 1, 2006.

———. Interview with Stephanie Sauer. May 27, 2009.

———. Interview with Stephanie Sauer. June 15, 2010.

Orosco, Juanishi, and Esteban Villa. Interview with Ella Maria Diaz. December 23, 2000. CSU Sacramento Archives.

Padilla, Stan. Interview with Stephanie Sauer for La Raza Galería Posada. July 1, 2004.

Quiñones, Samuel. Interview with Stephanie Sauer. July 7, 2004. LRGP Collection, CSU Sacramento Archives.

———. Interview with Stephanie Sauer. June 19, 2007.

Ramirez, Graciela. Interview with Stephanie Sauer. November 25, 2002. LRGP Collection, CSU Sacramento Archives.

Rasúl, David. Interview with Stephanie Sauer. June 15, 2007.

Ríos, Sam. Interview with Steve LaRosa. November 23, 1993. Collection of La Raza Galería Posada as of 2004.

Robles, Trudy. Interview with Stephanie Sauer for La Raza Galería Posada. June 16, 2004.

Romo, Terezita. Interview with Stephanie Sauer. July 6, 2002. LRGP Collection, CSU Sacramento Archives.

———. Interview with Stephanie Sauer. July 25, 2002. LRGP Collection, CSU Sacramento Archives.

Romo, Terezita, Malaquias Montoya, and Juan Carrillo. Personal Correspondence. Tapa the World Restaurant. May 21, 2007.

Serna, Joe. Interview with Steve LaRosa. July 5, 1994. Collection of La Raza Galería Posada as of 2004.

Serna, Manuela. Interview with Steve LaRosa. July 5, 1994. Collection of La Raza Galería Posada as of 2004.

Talamantez, Josie. Interview with Stephanie Sauer. July 19, 2002. LRGP Collection, CSU Sacramento Archives.

———. Interview with Stephanie Sauer. August 20, 2002. LRGP Collection, CSU Sacramento Archives.

———. Interview with Stephanie Sauer. July 21, 2004. LRGP Collection, CSU Sacramento Archives.

———. Interview with Stephanie Sauer. July 23, 2004. LRGP Collection, CSU Sacramento Archives.

Villa, Esteban. Interview with Stephanie Sauer. March 23, 2004. LRGP Collection, CSU Sacramento Archives.

———. Interview with Stephanie Sauer. July 14, 2007.

ARTICLES

Ackley, Michael. "Pride Is the Only Common Factor." *Sacramento Union*. p. A1. November 15, 1981. Print.

Ahlgren, Frank. "Border Clashes Linked to Terrorist Group." *El Paso Herald Post*. p. A1. May 19, 1977. Print.

Arrieta, Rosa. "Los Veteranos: Rene Yáñez." *El Tecolote*. August 24, 2006. http://news.eltecolote.org/.

"Barrio Education." *Azlo Magazine*. v.1 n.2. p. 6. October 1980. Print.

"The Best of Sacramento." *Sacramento Magazine*. p. 115. November 2002. Print.

Camacho, Eduardo. "Inaugurarán hoy en San Diego la Exposición 'Homenaje a Posada, Manilla y Vanegas Arroyo.'" *Excelsior*. Section E. February 14, 1980. Print.

Castro, Mike. "La Raza Reaches Back to Fund the Future." *Sacramento Bee*. p. E1. April 28, 1994. Print.

Cid, Armando. "The Days of the Dead Are Not a Hispanic Halloween!" *Califas*. v.1 n.2. p. 12. November 2004. Print.

"Cómo Nos Vemos?" *Pincel y Pluma: Newsletter of La Raza Bookstore and Galería Posada*. v.2 n.2. p. 2. October 1989. Print.

Dalkey, Victoria. "Companions of the Canvas: Co-Madres Artistas Celebrate 10 Years of Many, Many Art Shows." *Sacramento Bee*. p. Encore 1. July 14, 2002. Print.

———. "Casa Sacramento: La Raza Galería Posada Opens a New Center for Arts and Culture." *Sacramento Bee*. Sunday Ticket. p. 28. April 4, 2004. Print.

Dávila, Robert D. "Obituary: CSUS Professor, Artist Favela Promoted Latino Pride." *Sacramento Bee*. p. B5. July 20, 2007. Print.

Esparza Loera, Juan. "Chicano Power: Artistas se identifican con los campesinos." *Vida en el Valle*. v.18 n.34. p.1. August 20, 2008. Print.

Goldman, Jane. "Art against the Wall." *Sacramento Magazine*. p. 41. August 1980. Print.

Goldman, Shifra. "A Public Voice: Fifteen Years of Chicano Posters." Art Journal. v.44 n.1. Spring 1984. www.jstor.org.

"Homenaje a José Guadalupe Posada." *Voz Fronteriza*. 5.3. March 1980. Print.

Jones, Melissa. "A Whole Life: Through Dance, Art and Teaching, Frank LaPena Weaves Together Pieces from His Past." *Sacramento Bee*. p. E1. February 3, 2000. Print.

"La Mujer Chicana." *Alkali Review*. 2.15. April–May 1977. Print.

"Louie The Foot: Poet, Printer, Artist." *Alkali Review*. 6.12. October-November 1980. Print.

Martínez, Christopher. "Reclaiming Space: Poetry, Music, and Art of the Royal Chicano Air Force." *McNair Journal*. 1997. www.mcnair.berkeley.edu.

McGhee, Lakiesha. "Mural Makeover: Royal Chicano Air Force Artists Return to Southside Park." *Sacramento Bee*. p. B1. August 21, 2001. Print.

Montecón, Arturo. "Volveremos, Y Con La Frente Mas Marchita." *Pincel y Pluma: Newsletter of La Raza Bookstore and Galería Posada*. v.2 n.1. p. 1. June 1989. Print.

Montemayor, Robert. "Angry Artist of Mexico's Revolutionary Era." *Los Angeles Times*. p. 6. February 16, 1980. Print.

Montoya, Gina. "Breakfast for Niños." *Alkali Review*. 2.16. April–May 1977. Print.

"Primer Canto." *Pincel y Pluma: Newsletter of La Raza Bookstore and Galería Posada*. v.3 n.2. p. 2. June 1990. Print.

Quiñones, Sam. "Muralismo." *Azlo Magazine*. v.1 n.2. p. 28. October 1980. Print.

Romo, Terezita. "The Visual Poetry of Luis González." *Louie The Foot González: The Second Coming of Con Safos*, C/S and Raz'encia Exhibition Catalog. Sacramento, La Raza Galería Posada: 1993. Print.

Schwartz, Don. "Out Front on the Art Front." *Suttertown News*. p. 16. February 14–21, 1985. Print.

"Segundo Canto." *Pincel y Pluma: Newsletter of La Raza Bookstore and Galería Posada*. v.3 n.2. p. 2. June 1990. Print.

Sylva, Bob. "Reaching for the Sky: A New Home Gives La Raza Bookstore and Galería Posada the Chance to Expand the Link to Heritage." *Sacramento Bee*. p. E1. 1992. Print.

Talamantez, Josie S. "RCAF Pasandola Con Gusto: A Validation of the Present; Remembrances of the Past; and a Tribute to the Future." *El Cántaro: La Raza Galería Posada's Newsletter*. v.1 n.2. p. 2. January–March 2003. Print.

"United Nations Declaration on Rights of Indigenous Peoples." *Cultural Survival* (magazine). 2007.

Valencia, Manuel. "Chicano Art Renaissance Succored by Poet's Blood." *Sacramento Union*. p. E3. July 1, 1973. Print.

ARCHIVAL SOURCES

Centro de Artistas Chicanos II. Meeting Minutes. June 20, 2007. Brick-
house Art Gallery, Sacramento.

Centro de Artistas Chicanos II. Meeting Minutes. July 5, 2007. Brick-
house Art Gallery, Sacramento.

Centro Cultural de la Raza. Exhibition materials and correspondence:
100 Year Anniversary: Antonio Vanegas Arroyo, José Guadalupe
Posada, Manuel Manilla. May 28, 1980. California State University,
Sacramento Archives and Special Collections.

Gonzalez, Xico. *El Profe: José Montoya*. Video. Revoltoso, Inc., 2004.

La Raza Galería Posada. "California Council for the Humanities Califor-
nia Stories: Communities Speak." Grant Proposal, 2003. California
State University, Sacramento Archives and Special Collections.

La Raza Bookstore. Media Publicity for the José Guadalupe Posada Art
Exhibition. June 13, 1980. California State University, Sacramento
Archives and Special Collections.

LaRosa, Steve. *Pilots of Aztlán*. Video. PBS Documentary, 1994.

LaRosa, Steve. *Pilots of Aztlán: The RCAF Flies Again*. Video. PBS Docu-
mentary, 2008.

Pasado. Presente. Futuro. La Raza Galería Posada Fundraiser Event Cata-
log. May 3, 2003. Print. CSU Sacramento Archives.

EXHIBITION CATALOGS

Art of the Other México: Sources and Meanings. Chicago: Mexican Fine
Arts Center Museum, 1993. Print.

The Chicano Codices: Encountering Art of the Americas. Chicago: Mexican
Fine Arts Center Museum, 1998. Print.

Esteban Villa: A Survey of the Chicano Maestro. Sacramento: La Raza
Galería Posada, 1995. Print.

Favela, Ricardo. "Monfavil/A Royal Chicano Vintage." RCAF. Sacra-
mento: Creative Interprises, 1989. Print.

Hecho en Califas: The Last Decade 1990–99. Los Angeles: Plaza de la Raza,
2000. Print.

José Guadalupe Posada Aguilar. Chicago: Mexican Fine Arts Center Museum, 1988. Print.

José Guadalupe Posada and Taller de Gráfica Popular: Mexican Popular Prints. Stanford University Library, 2002. Print.

La Raza's Quinceañero. Sacramento: La Raza Galería Posada, 1988. Print.

Louie The Foot González: ¡Híjole! What Was I Thinking? Sacramento: La Raza Galería Posada, 2003. Print.

Miliotes, Diane, ed. *José Guadalupe Posada and The Mexican Broadside*. Chicago: Art Institute of Chicago, 2006. Print.

Montoya, José. "Los Compilots and Adobe Airplanes." *RCAF*. Sacramento: Creative Interprises, 1989. Print.

———. "La Raza Bookstore: The Early Years." La Raza Bookstore and Galería Posada 30th Anniversary Brochure, 2003. Print.

———. *Thoughts on La Cultura, the Media, Con Safos and Survival*. Galería de la Raza/Studio 24, 1979. Prepared for the First Annual Chicano Film Series, Stanford University, California. Print.

Norriega, Chon A., ed. *Just Another Poster: Chicano Graphic Arts in California*. Santa Barbara: University of California, 2002. Print.

Oro de Aztlán: El Arte del RCAF. Sacramento: Robert Else Gallery, CSU Sacramento, 1990. Print.

Romo, Terezita. *The Second Coming of Con Safos, C/S and Raz'encia: The Visual Poetry of Luis González*. Davis: C. N. Gorman Museum; Sacramento: La Raza Galería Posada, 1993. Print.

Royal Chicano Air Force Poster Art Exhibition. Sacramento: Festival de la Familia, 1992. Print.

Royal Chicano Air Force: 37 Years of Culture Con Cultura. Sacramento: La Raza Galería Posada, 2006. Print.

Sorrell, Victor A., ed. *Carlos Cortez Koyokuikatl: Soapbox Artist and Poet*. Chicago: Mexican Fine Arts Center Museum. 2001. Print.

Valdez, Luis. "Twelve O'Clock High on a Wing and Acrylic." *RCAF*. Sacramento: Creative Interprises, 1989. Print.

What We Are . . . Now. San Francisco: Galería de la Raza/Studio 24. 1980. Print.

Ybarra Frausto, Tomás, ed. *Chicano Expressions: A New View in American Art*. Chicago: Mexican Fine Arts Center Museum, 1986. Print.

LECTURES AND PRESENTATIONS

Diaz, Ella Maria. Educational Lecture. "The Necessary Theatre of the Royal Chicano Air Force." Galería de la Raza. January 22, 2011.

Favela, Ricardo. Educational Lecture. Washington Neighborhood Center, Sacramento. March 16, 2002.

Galván, Joaquin. Educational Lecture. "The Aztec Calendar." La Raza Galería Posada, Sacramento. May 24, 2004.

González, Louie "The Foot." Silkscreen Workshop. La Raza Galería Posada, Sacramento. 2002.

———. Artist Lecture. *¡Híjole! What Was I Thinking?* Exhibition. La Raza Galería Posada, Sacramento. March 8, 2003.

Güereña, Salvador. Educational Lecture. Society of California Archivists Annual Meeting. April 12, 2003.

Hernández Cruz, Victor. Poetry Reading. Hot House, Chicago. 2007.

Jefferson, Juanita. Educational Lecture. "Native American Archives." Society of California Archivists Annual Meeting. April 11, 2003.

Johnson, Patricia. Preservation Techniques Workshop. "¡Historias Vivas!" La Raza Galería Posada, Sacramento. August 28, 2004.

McCreery, Laura. Oral History Workshop. Contra Costa County Historical Society. September 6, 2003.

Montoya, José. Artist Talk and *Los Compas* Book Release. The Book Collector, Sacramento. July 7, 2010.

Montoya, José, Juan Carrillo, Louie The Foot, Rene Yáñez, Juan Fuentes, and Malaquias Montoya. *Just Another Poster* Exhibition Forum. Crocker Art Museum, Sacramento. July 31, 2003.

Montoya, Maceo, and Tomás Montoya. Artist Talk. *Los Primos* Exhibition: La Raza Galería Posada, Sacramento. June 27, 2007.

Orosco, Juanishi. Award Reception for Royal Chicano Air Force. Self-Help Graphics and Art 4th Annual *Corazones de Aztlán* Reception. March 22, 2003.

Ortiz, Chuy. Palabra. Danza Azteca: Washington Neighborhood Center, Sacramento. 2004–2005.

Padilla, Stan. Artist Talk. *Mezcla* Exhibition. La Raza Bookstore/Galería Posada, Sacramento. September 29, 2007.

raúlsalinas. Artist Talk and Poetry Reading. La Raza Galería Posada, Sacramento. 2003.

Villa, Esteban. Artist Talk. *Esteban Villa: Portraits* Exhibition. La Raza Galería Posada, Sacramento. May 17, 2007.

Yáñez, Rene. Curatorial Address. *RCAF: 37 Years of Culture con Cultura* Exhibit. La Raza Galería Posada, Sacramento. April 9, 2005.

BOOKS

Arroyo, Pedro. "The Political and Cultural Dimensions of Chicano Art as Studied in the Work of the Royal Chicano Air Force." Master's thesis. California Polytechnic State University: San Luis Obispo, 1997. Print.

Biegeleisen, J. I. *The Complete Book of Silkscreen Printing Production.* New York: Dover, 1963. Print.

Bierhorst, John, ed. *The Hungry Woman: Myths and Legends of the Aztecs.* New York: Quill, 1984. Print.

Billiers, Captain Alan. *Men, Ships and the Sea.* 7th ed. New York: National Geographic Society, 1973. Print.

Boone, Elizabeth Hill. *Stories in Red and Black: Pictorial Histories of the Aztecs and Mixtecs.* Austin: University of Texas Press, 2000. Print.

Bowen, Ezra. *Knights of the Air: The Epic of Flight.* New York: Time Life Books, 1981. Print.

Braidwood, R. J. *Prehistoric Men.* Chicago: Chicago Natural History Museum Press, 1948. Print.

Brands, H. W. *The Age of Gold: The California Gold Rush and the New American Dream.* New York: Anchor, 2003. Print.

Brown, Dee. *Bury My Heart at Wounded Knee: An Indian History of the American West.* New York: Holt, 2007. Print.

Burciaga, José Antonio. *Drink Cultura: Chicanismo.* Santa Barbara: Joshua Odell Editions, 1993. Print.

Campbell, Joseph. *The Power of Myth.* New York: Doubleday, 1988. Print.

Carrillo, Juan, and José Montoya. "Posada: The Man and His Art: A Comparative Analysis of Jose Guadalupe Posada and the Current Chicano Art Movement as They Apply toward Social and Cultural Change: A Visual Resource Unit for Chicano Education." Master's thesis. California State University: Sacramento, 1975. Print.

Chicano Park Mural Restoration Technical Manual. San Diego: Chicano Park Steering Committee Publication, 2006. Print.

Childe, Gordon V. *The Dawn of European Civilization*. New York, Toronto, and London: McGraw Hill and Co., Inc., 1965. Print.

Chilton's Repair and Tune-Up Guide for the Volkswagen. Philadelphia: Chilton Book Company, 1968. Print.

Clarke, Arthur C. *Man and Space*. New York: Time Life Books, 1964. Print.

Cockcroft, Eva Sperling, and Holly Barnet-Sanchez, eds. *Signs from the Heart: California Chicano Murals*. Albuquerque: University of New Mexico Press, 1993. Print.

Coe, Sophie D. *America's First Cuisines*. Austin: University of Texas Press, 1994. Print.

Colby, C. B. *Cliff Dwellings: Ancient Ruins of America's Past*. New York: Coward-McCann, Inc., 1965. Print.

Cortez, Carlos, ed. *¡Viva Posada!* Chicago: Charles H. Kerr, 2002. Print.

Davies, R. Trevor. *The Golden Century of Spain: 1501–1601*. New York: Harper Torchbooks, 1961. Print.

Del Techo, Nicolas, Bartolome Ximenez, and Martin Dobrizhoffer. *Tres Encuentros con América*. Editorial de Santerio, 1967. Print.

Deloria, Vine, Jr. *Red Earth, White Lies: Native Americans and the Myth of Scientific Fact*. Golden, CO: Fulcrum Publishing, 1997. Print.

Diaz, Ella M. "Flying under the Radar with the Royal Chicano Air Force: The Ongoing Politics of Space and Ethnic Identity." PhD diss. College of William and Mary, 2010. Print.

Diaz, Gisele, and Alan Rodgers. *The Codex Borgia: A Full-Color Restoration of the Ancient Mexican Manuscript*. New York: Dover, 1993. Print.

Donovan, Hedley, ed. *The High Sierra: The American Wilderness*. New York: Time Life Books, 1972. Print.

Emde, Heiner. *Conquerers of the Air: The Evolution of Aircraft 1903–1945*. New York: Bonanza Books, 1968. Print.

Evans, Susan Toby. *Ancient Mexico and Central America: Archeology and Culture History*. London: Thames and Hudson, 2004. Print.

Favela, Ricardo. "RCAF Retrospective Poster Exhibition: The Historical, Social, and Political Implications, 'In Search of Mr. Con Safos.'" Master's thesis. California State University, Sacramento, 1990. Print.

Federal Aviation Administration. *How to Become a Pilot: The Step-by-Step Guide to Flying*. New York: Sterling Publishing Company, 1987. Print.

Fraser, Douglas. *Village Planning in the Primitive World*. West Sussex: Littlehampton Book Services Ltd, 1968. Print.

Fuller, Gillian, and Ross Harley. *AVIOPOLIS: A Book about Airports*. London: Black Dog Publishing, 2005. Print.

Gallagher, I. J. *The Case of the Ancient Astronauts*. New York: Steck-Vaughn, 1997. Print.

Gilbert, James. *The Great Planes*. New York: Grosset and Gunlap and Ridge Press, 1970. Print.

Gillmor, Francis. *Flute of the Smoking Mirror: A Portrait of Nezahualcoyotl, Poet King of the Aztecs*. 1949. Print.

Goldston, Robert. *Spain*. New York: McMillan, 1967. Print.

Hale, John R. *Age of Exploration*. New York: Time Life Books, 1966. Print.

Hammond's Family Reference World Atlas. New York: Hanover House, 1962. Print.

Hawks, Nigel. *The Fantastic Cutaway Book of Spacecraft*. Brookfield, CT: Copper Beech Books, 1995. Print.

Homero Villa, Raúl. *Barrio-Logos: Space and Place in Urban Chicano Literature and Culture*. Austin: University of Texas Press, 2000. Print.

Josephy, Alvin M. Jr., ed. *The American Heritage Book of Indians*. New York: American Heritage Publishing Company, 1961. Print.

Berry Judson, Katherine. *Myths and Legends of California and the Old Southwest*. HardPress, 2008. Print.

Kershner, William K. *The Student Pilot's Flight Manual*. 5th ed. 1979. Print.

Kroeder, Theodora. *Ishi in Two Worlds: A Biography of the Last Wild Indian in North America*. Berkeley: University of California Press, 2002. Print.

León-Portilla, Miguel. *Pre-Columbian Literatures of Mexico*. Norman: University of Oklahoma Press, 1986. Print.

Loewen, James W. *Lies My Teacher Told Me: Everything Your American History Textbooks Got Wrong*. New York: Touchstone, 1996. Print.

Lucie-Smith, Edward. *Latin American Art of the 20th Century*. 2nd ed. London: Thames and Hudson, 2004. Print.

Mander, Jerry, and Victoria Tauli-Corpuz. *Paradigm Wars: Indigenous Peoples' Resistance to Globalization*. San Francisco: Sierra Club Books, 2006. Print.

McCarthy, General James P., USAF (RET), ed. *The Air Force*. Air Force Historical Foundation, 2002. Print.

McIntosh, Jane. *The Practical Archeologist: How We Know What We Know about the Past*. New York and Oxford: Facts on File Publications, 1986. Print.

Miller, Mary Ellen. *The Art of Mesoamerica: From Olmec to Aztec*. London: Thames and Hudson, 2001. Print.

Montoya, José. *InFormation: 20 Years of Joda*. San José: Chusma House Publications, 1992. Print.

Moolman, Valerie. *The Road to Kitty Hawk*. New York: Time Life Books, 1980. Print.

Padilla, Stan. *A Natural Education: Native American Ideas and Thoughts*. Summertown, TN: Book Publishing Company, 1994. Print.

———. *Chants and Prayers: A Native American Circle of Beauty*. Summertown, TN: Book Publishing Company, 1996. Print.

———. *Deer Dancer: Yaqui Legends of Life*. Summertown, TN: Book Publishing Company, 1998. Print.

Padilla, Stan, and Walking Night Bear. *Song of the Seven Herbs*. Summertown, TN: Book Publishing Company, 1987. Print.

Pearcy, Arthur. *Flying the Frontiers: NACA and NASA Experimental Aircraft*. Annapolis, MD: Naval Institute Press, 1993. Print.

Pictorial Atlas of the World. 2nd ed. New York: Rand McNally Publishing Company, 1897. Print.

Radio Technical Commission for Maritime Services. *Maritime Navigational Safety Information Sources*. 2nd ed., 1991. Print.

Rand McNally Encyclopedia of Transportation. Chicago: Rand McNally and Co., 1976. Print.

Romera-Navarro, M. *Historia de España*. Boston: Heath and Compañia, 1923. Print.

Ross, Norman P., ed. *Early Man*. New York: Time Life Books, 1965. Print.

Ruz, Alberto. *Palenque*. México, DF: Instituto Nacional de Antropología e Historia, 1973. Print.

Sands, Stella, ed. *Wright Brothers*. New York: Kids Discover, 2001. Print.

———. *Aztecs*. New York: Kids Discover, 2002. Print.

Siméon, Rémi. *Diccionario de la Lengua Nahuatl o Mexicana*. Colección América Nuestra-América Antigua, 1977. Print.

Technical Manual—Weather Manual for Pilots. Washington, DC: War Department, 1940. Print.

Trafzer, Clifford E., and Jule R. Hyer. *Exterminate Them: Written Accounts of the Murder, Rape, and Enslavement of Native Americans during the California Gold Rush*. East Lansing: Michigan State University Press, 1999. Print.

United States Department of Transportation Federal Aviation Administration. *Plane Sense: General Aviation Information*. 1999. Print.

Valdez, Luis, and Stan Steiner, eds. *Aztlán: An Anthology of Mexican American Literature*. New York: Vintage Books, 1972. Print.

Von Hagen, Victor Wolfgang. *Maya Explorer: John Lloyd Stephens and the Lost Cities of Central America and Yucatán*. Norman: University of Oklahoma Press, 1947. Print.

Ward, Anne. *Adventures in Archeology*. New York: Hamlin Publishing Group, 1977. Print.

Warhus, Mark. *Another America: Native American Maps and the History of Our Land*. New York: St. Martin's Press, 1998. Print.

Weatherford, Jack. *Indian Givers: How the Indians of the Americas Transformed the World*. New York: Ballantine Books, 1989. Print.

———. *Native Roots: How the Indians Enriched America*. New York: Ballantine Books, 1992. Print.

Young Williams, Mabel, ed. *California: A History*. Sacramento: California State Department of Education, 1965. Print.

Zilacis R., Dr. Luis. *Plantas Medicinales de México*. Columbus: McGraw-Hill, 1998. Print.

Fig. 137. La Stef, Index Note #22: Shifra Goldman on silkscreen as publishing, 2011. 3" × 5".

"The RCAF has also used the silkscreen poster as a substitute printing process for literature: an ingenious idea when one has little access to the publishing industry, which for years rejected Chicano manuscripts. (Chicano poets and writers still publish and distribute extensively through their own alternative press structures.)"

—Shifra M. Goldman

California College of Arts Archives

California Ethnic and Multicultural Archives, University of California, Santa Barbara

California State University, Sacramento Archives and Special Collections

Centro Cultural de La Raza, San Diego

Centro de Chisme Verdadero de SacrAztlán

Con Safos' Preservationists Society

David and Melinda Rasúl Private Collection

Galería de la Raza, San Francisco

Graciela Ramirez's House

La Colección Especial de Ella Maria Diaz, PhD

La Raza Bookstore and Galería Posada, Sacramento

Mexican Fine Arts Center Museum, Chicago

Museo del Barrio, New York City

Oral Vaults of the Royal Chicano Air Force

Sacramento Archives and Museum Collection Center

Samuel Quiñones' Video Archive

Sam Ríos' Garage

Serna Center, California State University, Sacramento

Smithsonian Air and Space Museum

Smithsonian American Art Museum Archives

Steve LaRosa Video Documentary Archives from *Pilots of Aztlán*

Tomás Ybarra-Frausto Papers of the Smithsonian American Art Museum Archives

LIST OF WORKS

Fig. 1. Stephanie Sauer, Index Note #1: Sacramento Magazine, 2011. 3" × 5".

Fig. 2. Stephanie Sauer, Evidence Bag: RCAF Postcard feat. General Confusion, 2009. Postcard design © Rene Villa. Courtesy of Rene Villa and Esteban Villa. 4" × 5.5". Photo by Jesse Vasquez. From the collection of Stephanie Sauer.

Fig. 3. La Stef, Founder of Con Sapos Archaeological Collective, 2012. Photo by Jon Alston.

Fig. 4. Stephanie Sauer, La Stef dog tag, 2008. Photo by Jesse Vasquez.

Fig. 5. Stephanie Sauer, Index Note #2: Nahuatl for History, 2007. 3" × 5".

Fig. 6. Miss Ella, Lead Cartographer of Con Sapos, 2012. Photo by Jon Alston.

Fig. 7. La Stef and Miss Ella in Old Town Sacramento, 2012. Photo by Jon Alston.

Fig. 8. L.A.S.E.R.I.U.M. Mural (Detail, North Wall by Esteban Villa), 2012. Photo by Jon Alston.

Fig. 9. Stephanie Sauer, Fiesta de Maíz sacred scroll. Photo by Jesse Vasquez.

Fig. 10. Stephanie Sauer, Untitled (Site of Armando Cid's missing "Sunburst" wall book), 2009.

Fig. 11. Stephanie Sauer, Index Note #3: CSUS Archives, 2008. 3" × 5".

Fig. 12. Stephanie Sauer, Index Note #4: Art History, 2007. 3" × 5".

Fig. 13. Stephanie Sauer, RCAF Prehistory, 2007.

Fig. 14. Stephanie Sauer, Inaugural Flight of LaRuca 2012. With permission of use of Los Files © Juanishi V. Orosco. Courtesy of Juanishi V. Orosco.

Fig. 15. Con Sapos Expedition Luggage Tag, 2011. From the collection of Stephanie Sauer.

Fig. 16. Stephanie Sauer, RCAF Evidence Bag: Adobe airplane. From the collection of Stephanie Sauer.

Fig. 17. Stephanie Sauer, Index Note #5: At Simon's Bar, 2005. 3" × 5".

Fig. 18. Stephanie Sauer, *Residencia de Santos Dumont plaque*, 2009. Santos Dumont Museum: Petrópolis, Rio de Janeiro, Brazil.

Fig. 19. Juanishi V. Orosco, Adobe Airplane, 2009. Photo by Jesse Vasquez. From the collection of Stephanie Sauer.

Fig. 20. Stephanie Sauer, Royal Chicano Naval Fleet, 2008.

Fig. 21. Ollín symbol. Artist unknown.

Fig. 22. Untitled (wind movement charts), 2011. Photo by Stephanie Sauer.

Fig. 23. Untitled (flattened reproduction of RCAF wind movement charts), date unknown. Source: Technical Manual—Weather Manual for Pilots. Washington, DC: War Department, 1940.

Fig. 24. La Espina del Maguey, 1969. From the Permanent Collection of the Con Sapos Nationalist Museum.

THIS PROJECT was able to take shape thanks in very large part to the financial, spiritual, and sometimes culinary support of a Corporation of Yaddo Fellowship, the School of the Art Institute of Chicago's Fellowship in Writing, the Byrdcliffe Colony, the Sacramento Metropolitan Arts Commission, and La Raza Galería Posada. My everlasting gratitude also extends to:

DR. ELLA DIAZ for everything.
JOSÉ MONTOYA for the palabras.
RICARDO FAVELA for introducing me to the other pilots.
JUANISHI OROSCO for the stories.
BETH NUGENT for allowing space for me to give myself permission.
MARGO HUNKINS for the consejos.
LOUIE "THE FOOT" GONZÁLEZ for the histories.
MARISA GUTIÉRREZ for taking a chance on a young intern from the hills.
TOMÁS MONTOYA for challenging my ways of thinking at the start.
IRA MURFIN for the coffees and questions.
JANET and ROBERT BALSER for the unofficial artist residency and the wooden boxes.
TATIANA REINOZA, SHEILA O'NEILL, CALVIN FORBES, DR. DEBRA MANCOFF, ROSELLEN BROWN, BILLIEMAE EISNER, RENE YÁÑEZ, THE CALIFORNIA COUNCIL FOR THE HUMANITIES, DOUG RICE, MEGAN DOUGLAS, DR. JOE MARTINEZ, ISABEL DOMENECH PRINCIPE, ALBERTO TELLEZ, KATHERINE HARBAUGH, JESSE BALL, ELLEN DORÉ WATSON, MERON HADERO, TIA BLASSINGAME, TONY SAUER, DR. TOM SIEGFRIED, AND ALL WHO TOOK THE TIME TO BE INTERVIEWED.

To ALL who made *The Ancient Documentaries of Southside Park* film project possible, including JOSÉ MONTOYA, SAMUEL QUIÑONES, ESTEBAN VILLA, JUANISHI V. OROSCO, JANELL LACAYO, RICHARD CHACÓN, GRACIELA RAMIREZ, JUAN CARRILLO, JOANN ANGLIN, ART LUNA, JOHN E. MÁRQUEZ, and GALERIA DE LA RAZA: ¡muchísimas gracias!

. . . and a deep thank you to RACHEL GONTIJO ARAUJO para as bolhas.